DANIEL GAUJAC

DO IT THE FRENCH WAY

Photos by Simon Upton
Drawings by Pénélope

STEIDL

CONTENTS

THE FRENCH CALL IT 'L'APÉRO'!

Can you imagine the unlikely scenario of a French dinner party, where the assembled guests did not share an enthusiastic conviviality, not only delighting in and savouring the taste of every delicious mouthful of food, but also anticipating the realm of possibilities conjured by the next drink to be served?

When it is a question of indulgence, the French are past masters! They are skilled in the art of endless chat, segwaying smoothly between the then, the now and the time to come, allowing a subtle nostalgia to pervade their innate sense of creativity.

Take for instance that blissful moment when it is time for the apéritif. The French say *l'apéro,* a colloquialism which encapsulates the true meaning of that precious time, an informal chapter in one's life reserved for friends, bottles and conviviality. *L'apéro* existed long before the concept of a drink 'after work' or the commercial invention of the 'Happy Hour'. This is where our art of teaching an old dog new tricks reaches its peak.

The legend behind *l'apéro* is linked to some of the most famous names to hit the world cocktail stage: the poetic, dreamy liquidity of the 'green fairy' that is Pernod Absinthe; the subtle gentian scent of Suze; Lillet's bitter-sweet orange symphony; the intense quinine power of Byrrh … and as a climax, Ricard's 'super star anise' shining in the cocktail firmament!

That was before… Let's forget all that ancient, glorious history. Let's look to new fame and future recognition.

In perpetuating the French paradox, yesterday's celebrities have become today's 'must haves' without any change in the bottles or their contents. Those contents are full-bodied, pure, highly-crafted and perfectly-balanced jewels that continue to inspire the best bartenders in the world today to create timeless, taste-enhancing and stylish cocktails. French patrimony is now expressed and reinterpreted in the excitingly new global trend in cocktails.

So, what lesson do we draw from this? Essentially, that nothing has changed. French cocktail culture, anchored in its sense of 'authenticity and conviviality' is a culture that, today, the whole world wishes to share.

If the French are still keen on *l'apéro* then why don't we *all*…

…'Do it the French Way'?

THUIR
RENAISSANCE

If A stands for Absinthe and B stands for Byrrh, then P clearly stands for Pernod and for passion. Passion is at the root of the revival of Alexandre Gustave Eiffel's iconic warehouse building at the heart of the town of Thuir in the Pyrénées-Orientales. Passion is behind Pernod's decision in 2011 to reintroduce absinthe, banned for nearly a century. Passion is what drives all employees from Pernod, the company that is responsible for restoring the integrity of a unique family business and for re-inspiring a workforce to revive an industry, which has been the lifeblood of generations of local families. A passion, which is inspiring bartenders and mixologists the world over to invent new cocktails around a classic French spirit and which is encouraging a new generation of consumers to embark on the rediscovery of what once was heralded the taste sensation of the 20th century.

This is a story which explores the roots of conviviality, the importance of legacy and the search for perfection. It is a story which uncovers the energy and expertise behind the revival of three uniquely French spirits: Pernod Absinthe, Byrrh and Suze.

So where did it all begin?

The narrow streets and sleepy cafés of the southern French town of Thuir, a short distance from Perpignan, give the 21st-century visitor no hint of the

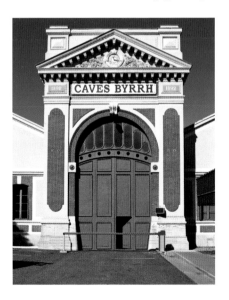 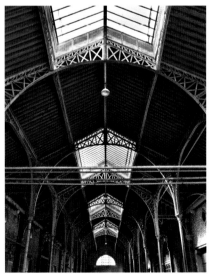

hustle and bustle that would have characterised this once thriving community, and where the majority of the townsfolk, often several generations of the same family, would have been gainfully employed by the distillery whose impressive buildings still dominate the town.

In 1855, like any ambitious young man of the day drawn to the new possibilities offered by the Industrial Revolution, brothers Pallade and Simon Violet arrived in Roussillon to seek their fortune. Their commercial venture began in a small way, selling fabric, haberdashery and wine off the back of a wagon, but it was the wine sales that started to take off and business was quick to expand through the import of wine from neighbouring Spain.

Not content to be a mere distributor however, Simon Violet nurtured an ambition to create his own version of the *medicinal wine* so popular with consumers at the time; but his would be based on quinine and would be distributed through the pharmacies. Rumour has it that Violet owed his knowledge of plants and their individual and distinctive flavours in part to a godfather who was a monk with an excellent palate, which enabled him to develop and produce his first 'tonic wine with quinine', making good use of the full-bodied Côtes du Roussillon supplied by local vineyards. With his secret recipe patented in 1873 and given the name of Byrrh, the first bottles

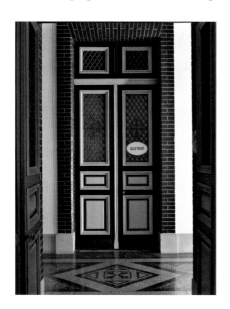
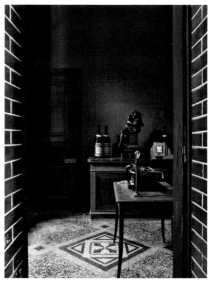

were available in 1892, followed in 1899 by the first distribution of Suze, a bitters flavoured with the aroma of wild gentian, considered a 'celebrity' among French aperitifs of the time and which was invented in Paris by Fernand Moureaux in 1885. Both brands enjoyed the accolade of being the number one drink in France in their day.

By 1876, the Violet brothers had set up their first business and the popularity of Byrrh had so far exceeded local consumption that they expanded into Spain, while at the same time setting about the construction of a series of warehouses in Thuir capable of storing five million litres of their special aperitif. As business continued to expand, this proved to be a short-term solution and Simon Violet came up with a scheme to build a series of much larger warehouses, with the factory linked directly to the railway. He invited France's star architect of the time, Alexandre Gustave Eiffel, to supply the wow factor and to create a showpiece worthy of Byrrh's growing status on the international stage. By 1910 and with descendants of the Violet brothers at the helm, the company had 750 employees and provided work for 20,000 families around the world.

Like many other businesses in Europe, things were never the same after two World Wars, and in 1961 the surviving members of the Violet family sold

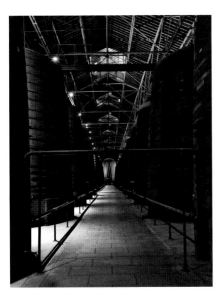
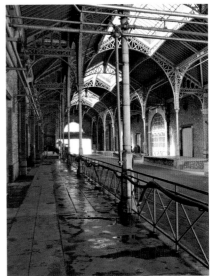

the firm to the Compagnie Dubonnet-Cinzano, which in turn was acquired in 1976 by Pernod-Ricard, the world's leader in the premium spirits industry.

By then the distillery had fallen on hard times, with many of its regional brands considered unfashionable and unable to compete with those more internationally recognised. Pernod decided upon a project of restoration, not simply to save Eiffel's landmark building, but also to revive the popularity of spirits for which the distillery had once enjoyed world acclaim.

Thuir was the obvious location to recreate the story of classics such as Byrrh and Suze, as well as to reintroduce Pernod Absinthe. Each is a plant-based spirit and, with the exception of wormwood, the ingredients are grown close to the distillery and the wine comes from local vineyards. The combination of the three brands has a strong historical and very French thread, and the Thuir distillery provides the craftsmanship, the distillation and an irrefutable legacy.

While Byrrh originated in Thuir at the end of the 19th century, absinthe dates back to the time of the French Revolution a century earlier, when French loyalists fled the country for the safety of France's neighbours. One such elderly exile to Couvet in Switzerland is alleged to have created a new elixir based on a combination of plant extracts and wormwood, which was considered

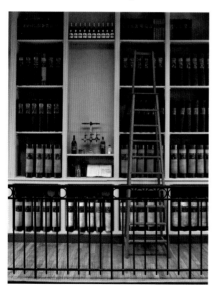
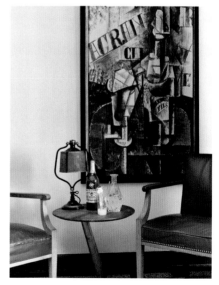

to have medicinal properties. The result was too bitter and, in an attempt to make his elixir more palatable, he combined the botanical ingredients with distilled grape juice to create a tonic, which he called Extract of Absinthe.

No matter the truth behind the who, the where is not in dispute and the village of Couvet is acknowledged as the place where absinthe first originated. It was also in Couvet, towards the end of the 18th century, that the first commercial distillation of absinthe as a drink, rather than an elixir, was initiated by one Abram-Louis Perrenoud, whose son, Henri-Louis, changed his name to Pernod, and in 1805 established his own manufacturing company, Pernod Fils, in the French town of Pontarlier where the story of the Pernod Absinthe brand continued. Compared with other more bitter quinine-based tonics on the market, absinthe proved popular, its success due in part to favourable reports of French army doctors prescribing it to soldiers in the 1840s Algerian Campaign to prevent malaria and other fevers.

The favourite aperitif of Paris's bohemian set in the 19th century, which included Oscar Wilde, Baudelaire and Toulouse-Lautrec, soaring sales led inevitably to concerns about the overconsumption of absinthe. Tales of its adverse effects were highly exaggerated, giving rise to an increasingly bad and allegedly harmful reputation, which resulted in a ban on the drinking

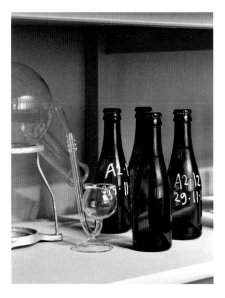
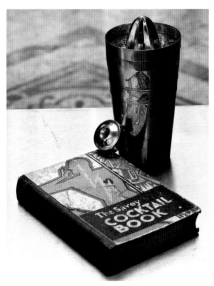

of absinthe in several countries at the start of the 20th century and in France by January 1915.

The combined effect of World War I and the French ban on absinthe dealt a heavy blow to the company of Pernod Fils and it was not until 1926 that, in partnership with Hemard Distillery, an anise-flavoured liqueur called Pernod was created, which, without the wormwood ingredient banned in absinthe, proved to be a welcome substitute for French consumers. The launch of Pernod Anise, which still plays an important part in the company's portfolio of spirits today, was to save the Pernod name.

In May 2011, after nearly a century of prohibition, the French ban on absinthe was lifted and in 2013 at the Thuir distillery, by then restored to its former glory, Pernod re-launched its classic Pernod Absinthe, made to an original recipe.

What is the definition of a classic in the 1800s? Classic in this context might be used to describe both the architecture of the Thuir distillery as well as the brands it once produced and distributed. The distillery has stood for over a century, during which time the over-engineered strength of Eiffel's infrastructure, its soaring iron columns and magnificent roof supports have survived war, neglect and change. The recipe for Pernod Absinthe is also a

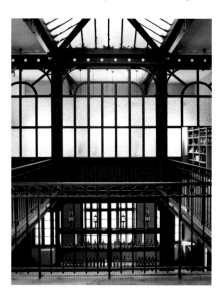
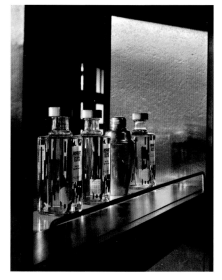

hundred years old and, with access to archive records, it has been faithfully recreated. What better backdrop for its re-launch than the enduring power and strength of Eiffel's showpiece?

A shared conviviality is Pernod's touchstone and, together with brand consultant Vaughan Yates and Eric Fossard, a renowned drinks consultant, the company was determined to create a special place at the heart of the Thuir distillery, which would bring bartenders, guests and media together to celebrate the revival of Pernod Absinthe and to reintroduce Byrrh and Suze to a new audience.

Global brand consultants 1751, under its director Vaughan Yates, experts in delivering experience-led drinks environments, so-called 'brand homes', are specialists in this very niche industry and have a history of collaboration with Pernod. They worked closely with Spanish architect Rafael Gallego and Patrick Guidici, the manager of the distillery, who supplied local tradespeople to help with the transformation of a disused office, vacated by the typing pool in the 1950s, into an eye-catching contemporary bar – Thuir's surprising and best-kept secret.

While early 20th-century black-and-white archive photographs of the room were encouraging, the first site visit found it to be in poor condition and

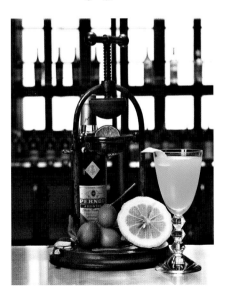
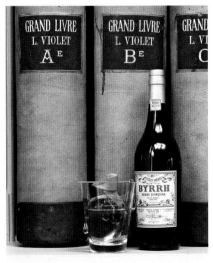

at that stage there was no clear picture of how Pernod wished to make best use of the space.

There was a lot of dust! Decades-old partitions and false ceilings crumbled without resistance to the new broom sweeping through the building, revealing behind the temporary compartmentalisation a hitherto concealed mezzanine floor.

Eiffel's significant architectural legacy, his innate understanding of space and the revelation of a double-height room to play with all had a bearing on the design of the new bar. It became immediately obvious, standing on the newly uncovered mezzanine floor and looking down through Eiffel's beautifully crafted balustrade, that the horseshoe-shaped bar should be sited right in the centre of the room, making it a real showcase for the brands.

It also became apparent that the bird's eye view of bartenders working on cocktails (usually prepared secretively below the *zinc* and away from the eyes of the consumer) would prove to be amusing, educational and inspirational, encouraging a good exchange of ideas, competition and banter, and creating a truly special and conducive environment in which individual bartenders could shine and share their skills.

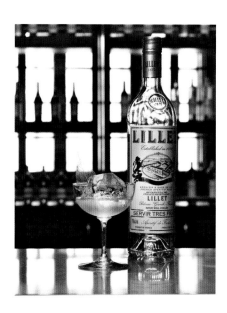
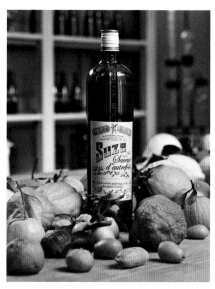

For their part, 1751's designers were determined to achieve a timeless interior that would complement Eiffel's 20th-century vision. The choice of furniture is subtle and low key, sourced from independent cabinet-makers and furniture designers, recreating the atmosphere of an English colonial club. The soft, gun-metal grey of the decoration echoes Eiffel's industrial infrastructure, while vintage lamps and low lighting contrive an intimacy in a space, which is also capable of hosting a hundred people comfortably.

Bottles, some of them priceless vintage examples, are displayed on a suspended signature wall – a pair of sliding doors with backlit shelves – which provides a theatrical backdrop to the centrally positioned bar, a reminder of a Paris of times gone by and the bars and cafés where absinthe would regularly have been consumed.

For Pernod the most important element of course is the product itself, but who makes it and how it is made is equally so, and in order for it to be acknowledged, a brand also needs to have a recognisable provenance.

So the Thuir distillery, the original source of Byrrh, is now also home to Suze and Pernod Absinthe. As word of the new bar spreads through the industry, Pernod's aim is to encourage and attract a new and interested

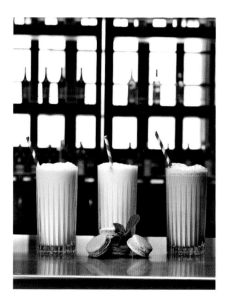
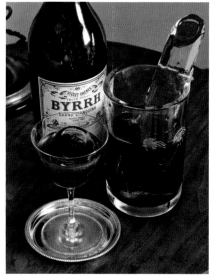

clientele and to afford individuals an opportunity to taste, share and enjoy the company's vast array of spirits in a conducive, exciting and vibrant new environment.

Bartenders are invited to come and experience for themselves the aura and atmosphere of the place where the product they are mixing is actually created, as well as to meet the people behind the creation. At the same time, this gives the workforce at the distillery an insight into what happens once the product has left the warehouse.

What is clear is that without the bartenders, cocktail makers and mixologists, the drinks are just drinks and there is only one way of consuming them. With a barman's inventiveness and creativity, a whole new and diverse world opens up for the consumer, elevating the product and essentially bringing it to life. Both producer and bartender now see the brand from the opposite end of the spectrum and understanding would seem to have come full circle.

The message and the extraordinary sense of heritage at Thuir are also starting to get through to visitors to the distillery. The cleanliness and modernity of the 21st-century laboratory and the distillation area contrasts with

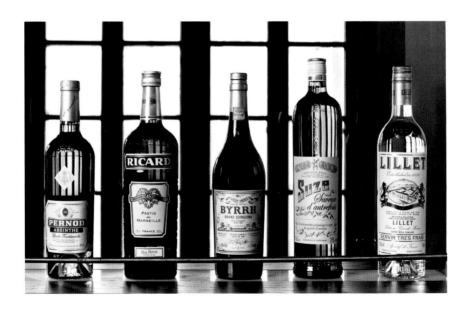

the impressive antiquity of the massive oak casks where the spirits ferment, the air in the *caves* heady with the fumes of the alcohol – proof, if any were needed, of how Pernod has retained the historic essence of the factory, yet fully embraced the methods of the 21st century.

History tells of the understanding which the writer Ernest Hemingway shared with a particular bartender at Harry's Bar in Venice. Then, as now, ideas, emotions and a sense of sharing continue to produce new cocktails – recipes are never definitive, the addition of something unexpected can change the taste in a second. A bar connects the dots between the drink and the glass as well as between people – the bar is the 'temple of conviviality'. It is about choosing not to drink alone, preferring the community of a bar, where you can meet people without the need of an introduction.

What is clear is that 21st-century consumers have embraced the excitement and passion of making, inventing and sharing cocktails and savouring classic drinks from a bygone age.

Today Pernod Absinthe, Byrrh and Suze are currently served in some of the most select bars around the world, which include Lab Bar, Montreal; Quinary, Hong Kong; Barules, Shanghai; El Floridita, Havana; Bar Trench, Tokyo; Ruby, Copenhagen; L'Antiquaire, Lyon; Papa Doble, Montpellier; Little Red Door, Paris; Mary Celeste, Paris; Le Lion • Bar de Paris, Hamburg; Mauro's Negroni Club, Munich; The Clumsies, Athens; Boutiq'Bar, Budapest; Bar Benfiddich, Tokyo; Door 74, Amsterdam; Licorería Limantour, Mexico City; Delicatessen, Moscow; Mr Help & Friends, Moscow; Salmon Guru, Madrid; Tjoget, Stockholm; Joyeux Bordel, London; Sardine, London; Mace, New York; Dante, New York. The list continues to grow.

Back in Thuir, Pernod continues to do things the French way, focusing on the popularity of the French *art de vivre*, the French approach to aperitifs and above all the promotion of a uniquely French spirit: absinthe.

Constructed in 1892 and at the height of his remarkable career, the massive scale of architect Alexandre Gustave Eiffel's grand entrance to the Thuir distillery dwarfs the neighbouring buildings.

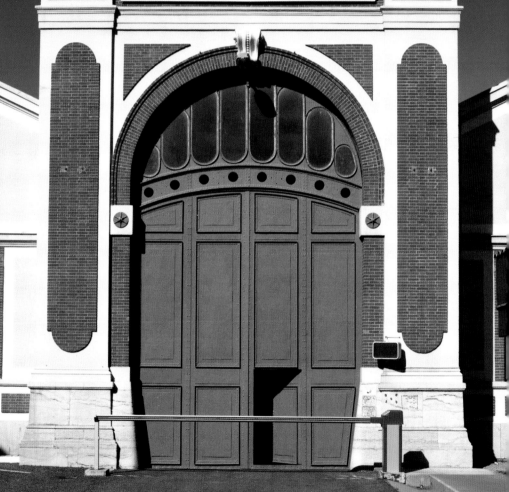

The over-engineered strength of Eiffel's infrastructure, its soaring iron columns and magnificent roof supports have survived war, neglect and over 120 years of change.

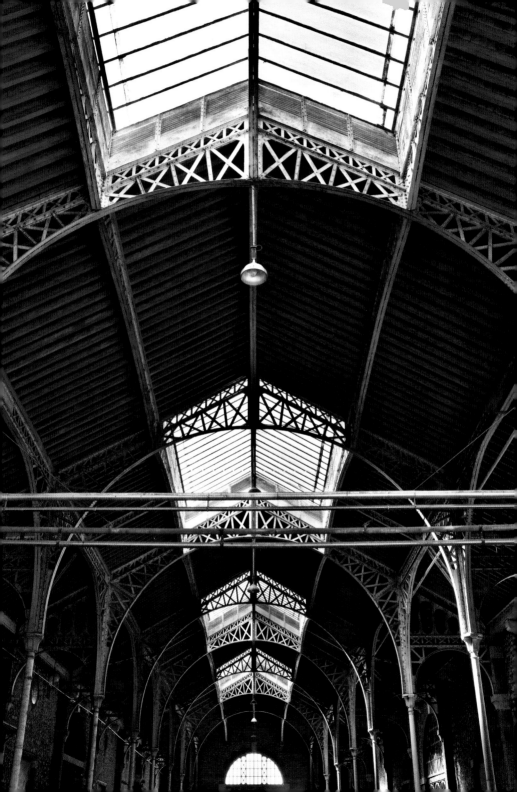

Eiffel's significant architectural legacy is revealed at its best in the distillery's loading area, with its double-height, iron-framed windows and the intricate design of its industrial roof supports.

The distillery was built in the middle of the local vineyards and this area, known as the *quai de chargement,* was designed with its own railway track to enable trains, loaded with fresh grapes, to be driven directly into the building.

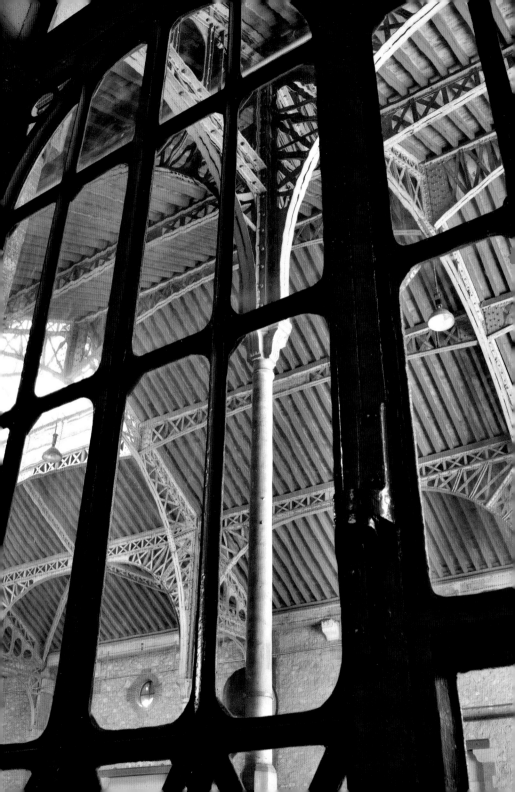

The Thuir distillery boasts the largest oak cask ever built, glimpsed here in the *cave* at the end of one of several walkways separating the rows of 70 casks used to ferment Byrrh and other fortified wines. With a total capacity of over 15 million litres, this makes it the largest cellar in the world. In the 1950s, when 30 million litres of Byrrh were sold on the French market, the *cave* would have stored barely six months' production.

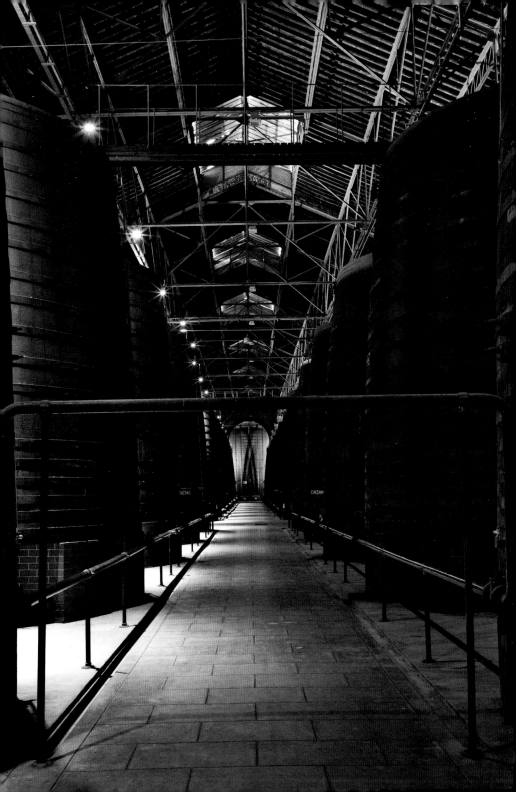

This is the largest cask for fermenting wine in the world. It took nearly 15 years to build and contains a staggering 1,000,200 litres. The wood was planted in the time of Louis XIV in a forest of oak trees that would have been destined for the French Navy. Its massive girth is secured with bands of Swedish steel.

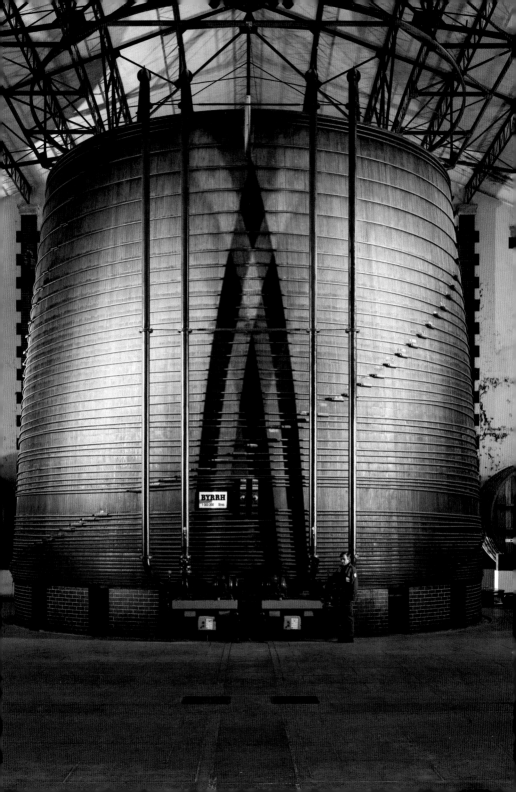

Thuir's Master Distiller, Guy Palmerols, keeps the recipes for his precious elixirs, Pernod Absinthe, Byrrh and Suze, a closely-guarded secret.

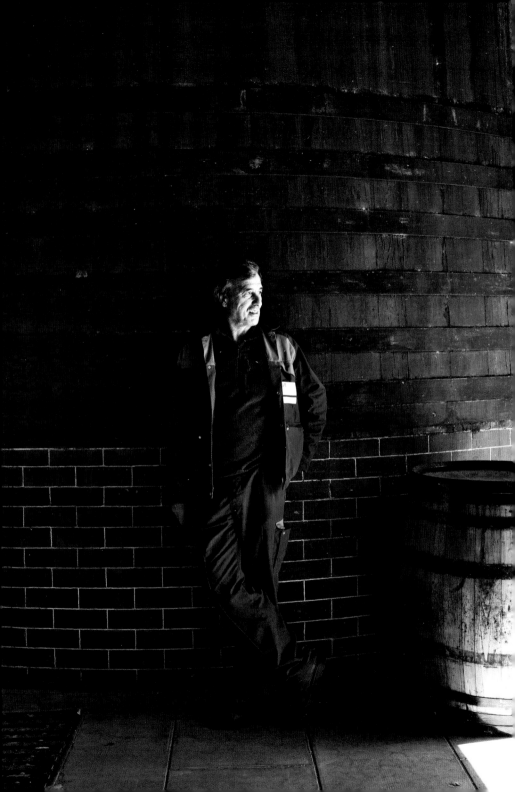

Original burnished copper stills, now museum pieces, are displayed in the entrance to the distilling hall.

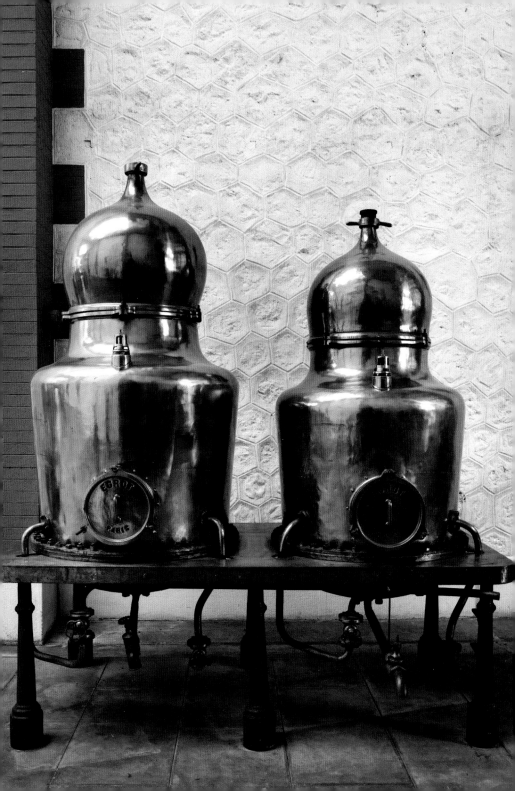

The original late 19th-century control panel in the distillery's vast *cave.*

CENTRALISATEUR DAUBRON

BO

FERMÉ

REFOULEMENT POMPE N°1

REFOULEMENT POMPE N°2

ANNEXE N°3

FERME

REFOULEMENT POMPE N°2

REFOULEMENT POMPE N°1

ANNEXE N°

GAUCHE

DROITE

FERMÉ

ASPIRATION POMPE N°1

FABRICATION

ASPIRATION POMPE N°2

FERMÉ

FABRICATION

ASPIRATION POMPE N°1

ASPIRATION POMPE N°2

Innovation and quality control are high on Pernod's list of priorities, while at the same time the company is forever refining and improving taste sensations for its consumers. Experiments with new flavours are carried out in the quiet recesses of the distillery's laboratory.

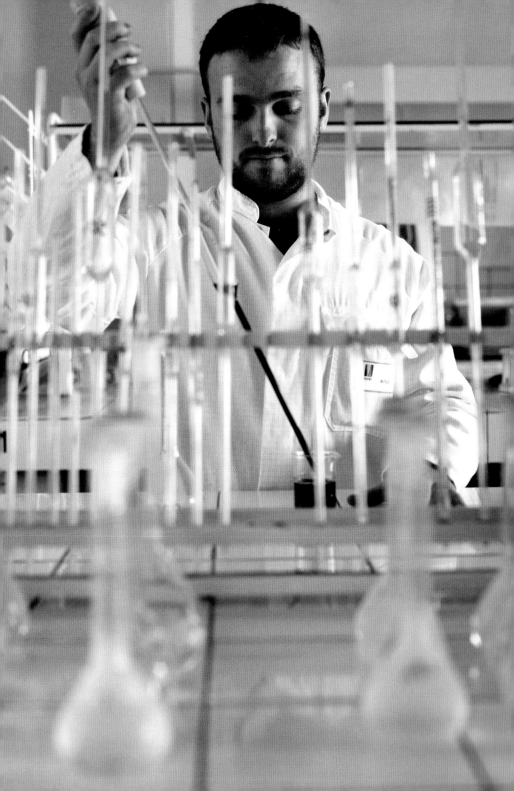

Every step of the production process as well as each batch is controlled using modern technology and proven equipment such as densimeters and alcometers. Experiments in distillation and the creation of new recipes are carried out in the white-tiled cleanliness of the laboratory. Research and Development also works from the archive to recreate the glorious tastes of the past, such as the original Pernod Absinthe that was reintroduced in 2012, Byrrh Grand Quinquina and Suze Saveur d'autrefois.

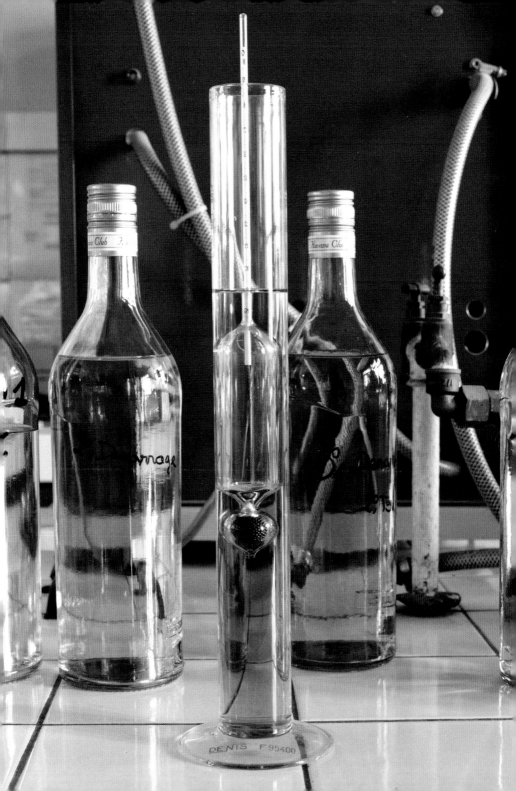

The green walls of the *Salon Vert* are lined with wooden cabinets displaying black-and-white archive photographs depicting the day-to-day life of the Thuir distillery.

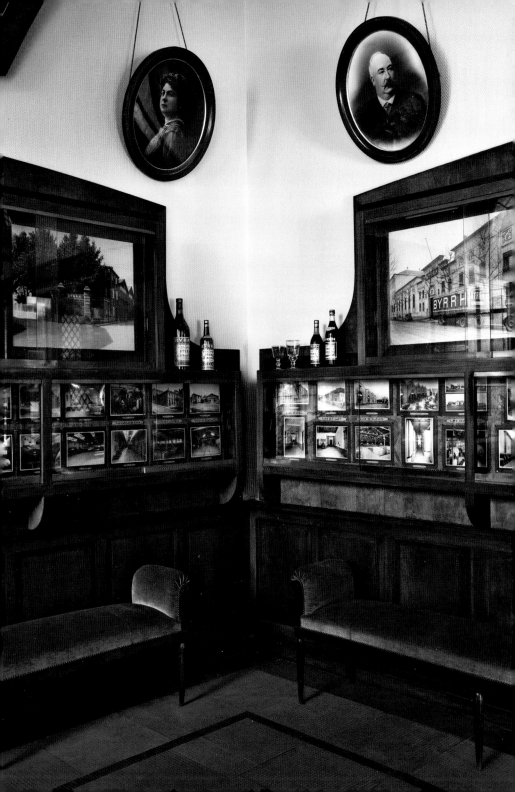

A series of panelled double doors, each heralded by a framework of polished red brick, leads off the distillery's main office corridor – this one opening into the *Salle Violet* (named after the Violet brothers who founded the distillery).

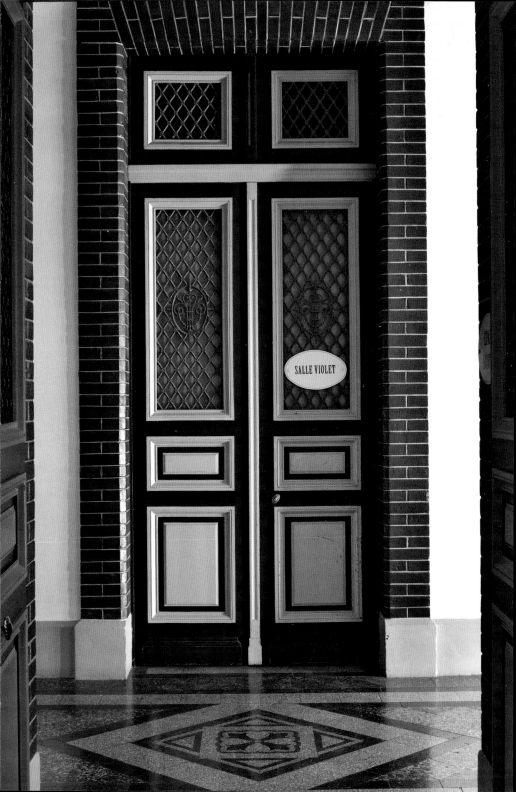

The open doors to the *Salle Violet* reveal the office of the foreman, who a century ago would have been in charge of up to 700 workers. The original geometric patterned stone floor and the small office area is furnished with a freestanding table and a vintage typewriter.

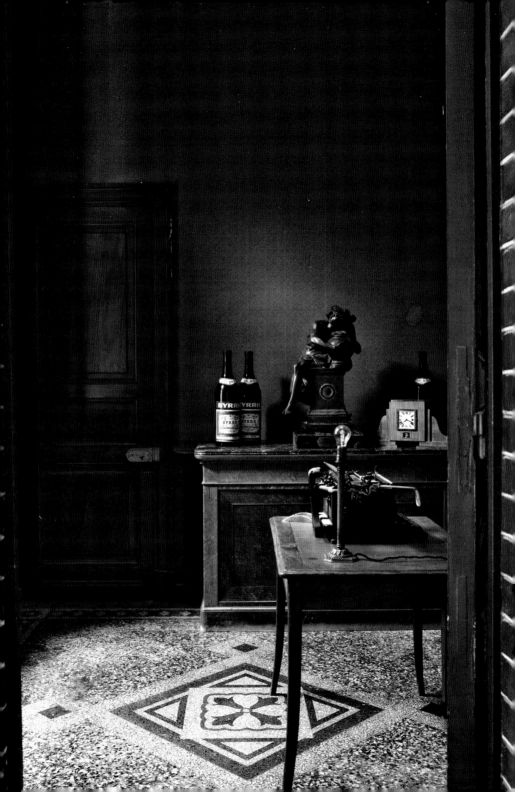

The Mixology Room is distinguished by its dramatic red-and-white marble work surfaces and inlaid cupboards, and would once have been used to invite customers to taste new products before buying them. Featured here, the famous Absinthe fountain, which has been used for more than a century to serve Absinthe by the glass, ensuring it tastes its very best.

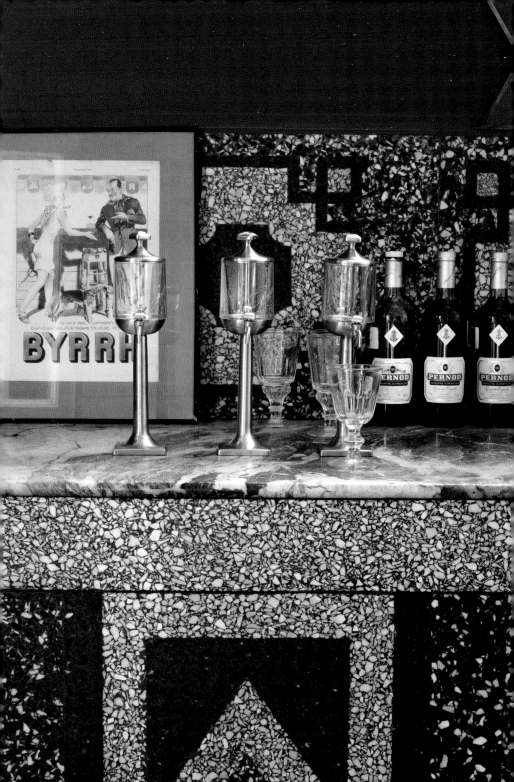

During the restoration, decades-old partitions and false ceilings were removed to reveal a hitherto concealed mezzanine floor with a beautifully crafted iron balustrade and original skylight, both the work of Alexandre Gustave Eiffel.

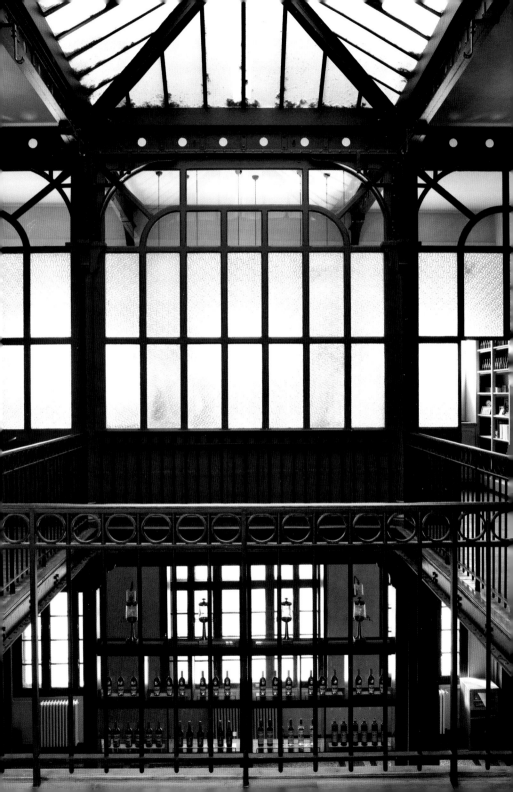

Green-painted industrial columns on the Mezzanine provide the infrastructure for a central iron balustrade and an industrial skylight, which affords natural light to the floor below where the new bar is now located. Faded green suede-bound ledgers, interspersed with shelves of vintage bottles are displayed around the walls of the Mezzanine.

The ledgers contain the export records and travel expenses of sales reps dating back to when the distillery was first opened, and were deliberately designed this large so that they could not be removed from the premises unnoticed!

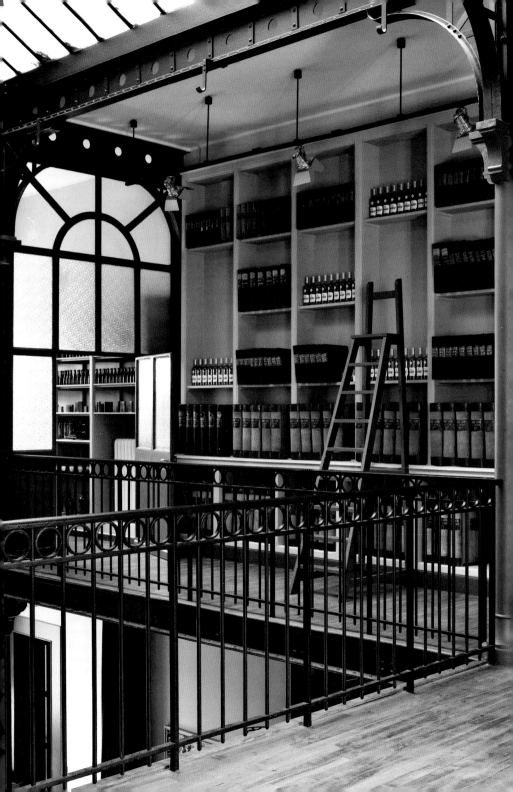

Clients are classified in alphabetical order with some still current customers dating back to as early as 1872.

Antique ledgers, dating to the foundation of the distillery, serve as a nostalgic backdrop for a Violet Negroni, a Byrrh cocktail named after the Violet brothers: a shot and a half of Byrrh, one shot of Suze, one shot of gin and two dashes of orange bitters to create a signature, bittersweet taste.

In the newly refurbished bar area a pair of vintage leather-clad armchairs is placed beneath an original Victor Brugairolles painting from 1903. In that year Brugairolles won the competition for the Byrrh poster over two hundred other Parisian artists. The winning painting features Pan, the Greek god of joy, in the combined form of man and goat, together with a goddess and a young satyr sitting on Mount Panassus. The three of them are enjoying Byrrh, presented as a 'constitutional tonic and a fortified wine with quinine'.

A retro wooden table displays a vintage Byrrh bottle from the 1950s and a glass of Byrrh 'on the rocks'.

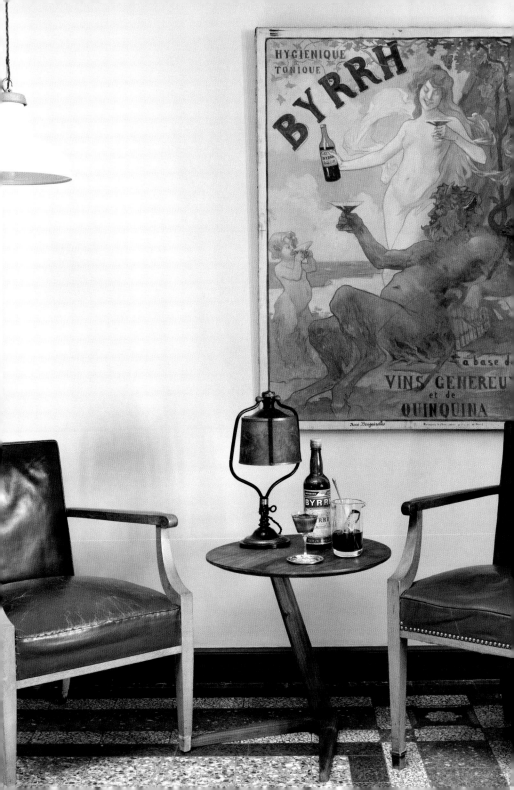

In the bar, a glass of Byrrh 'on the rocks' from the current bottle.

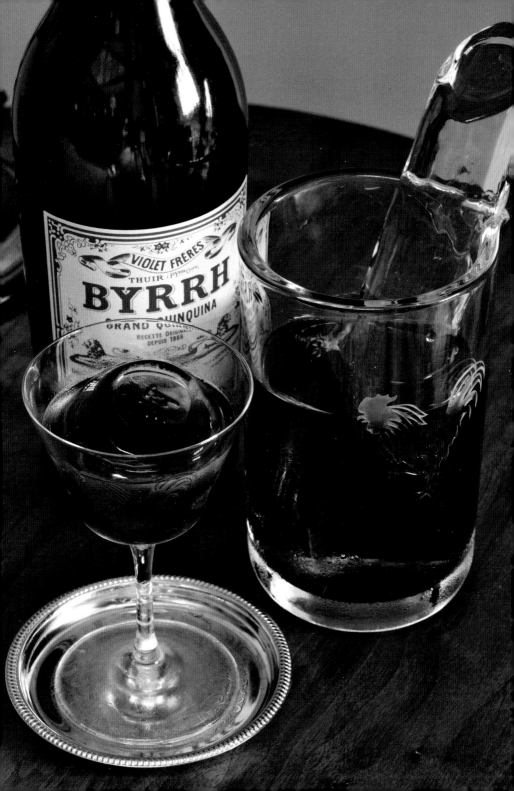

A framed reproduction of Pablo Picasso's *Bouteille de Pernod et verre* (1912) hangs above a vintage seating arrangement in the bar. The still life in this painting is replicated on a table in the bar: a vintage bottle of Pernod from the 1940s and antique water bottle. Pernod is more subtle than a classic pastis as it is 40 proof. The flavour of anise is fresher, because it contains less liquorice, and the taste is milder. A glass of Pernod typically features green anise and fennel notes with nuances of mint, orange and coriander that are also part of the bouquet.

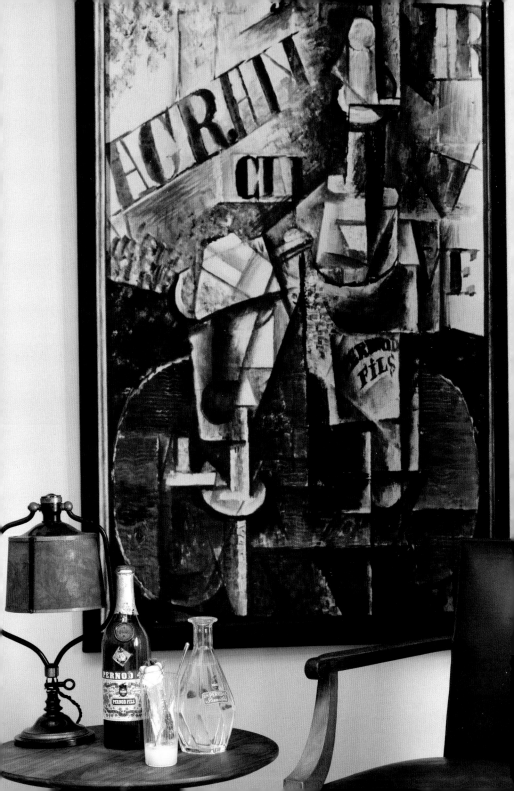

A retro lamp on a table in the bar, beneath an antique poster by Felix Valloton, features a 1950s Suze glass water bottle and ice bucket with a glass of Suze 'on the rocks' in the centre. A dash of water can be added according to taste.

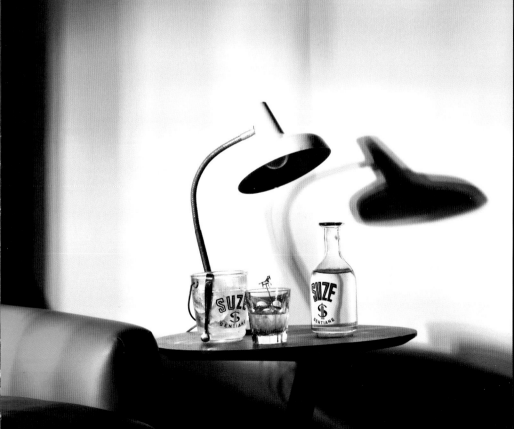

A White Negroni: Suze, Lillet and (preferably Plymouth) gin in equal parts – a cocktail originally created by Wayne Collins during Vinexpo 2001 in Bordeaux. A vintage French jigger is used for measuring, a bar spoon for stirring and a julep strainer on top of the mixing glass to retain the ice cubes when serving. Grapefruit peel is twisted over the glass to release aromatic essential oil and notes of citrus to create a bitter sweetness in the cocktail.

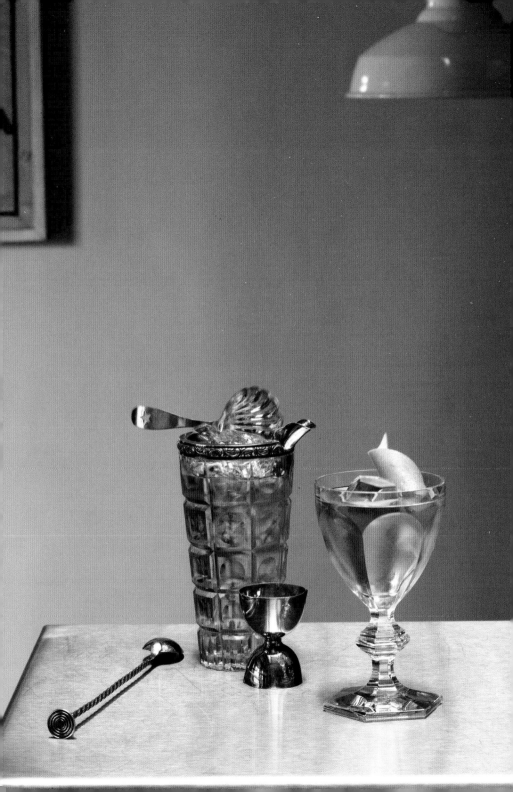

A vintage bar stool and distillation apparatus used for laboratory experiments are glimpsed through an open door in the glass partition that separates the Museum from the Mezzanine. This is a secret room, used for tasting the subtle variations in recipes in Pernod's endless search for perfection.

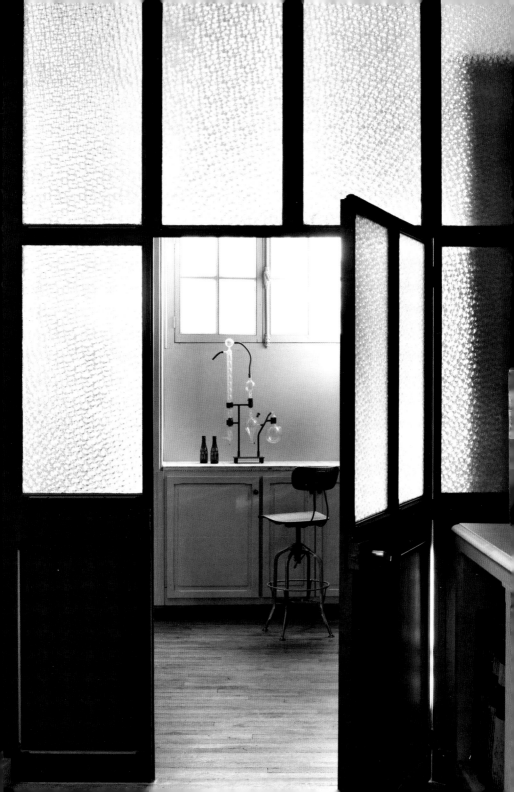

A collection of vintage conical flasks is grouped on the wooden table in the Museum with Suze Tonic in a highball glass. The gentian root placed beside the glass is a key ingredient in the composition of Suze and comes from the Auvergne. Gentian needs to be cultivated for 20 years before being macerated for a further 18 months and then distilled to produce Suze as we know it.

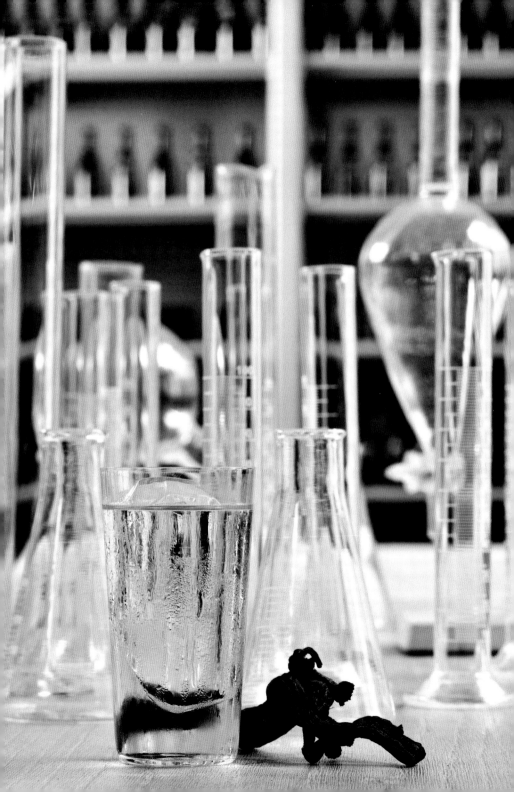

A bottle of Suze Saveur d'autrefois is surrounded by an assortment of locally-grown citrus fruits from Bachès, in Eus, a mere 15 kilometres from the distillery. Orange notes are an important part of the Suze signature. Kumquat, caviar lime, bergamot and rare varieties of citrus fruit, such as *cedrats, bigarades* and *combava,* remind us of the key roles citrus fruit plays in balancing the final taste of this bitter cocktail.

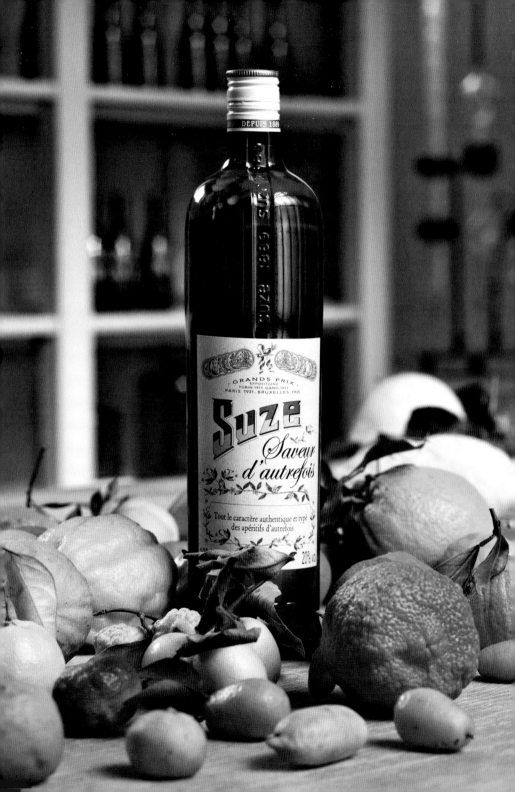

The grey-painted shelves in the Museum display a variety of tools. *Ludions* were used to adjust the density of the spirits during production.

A small distillation and rectification column used for lab testing.

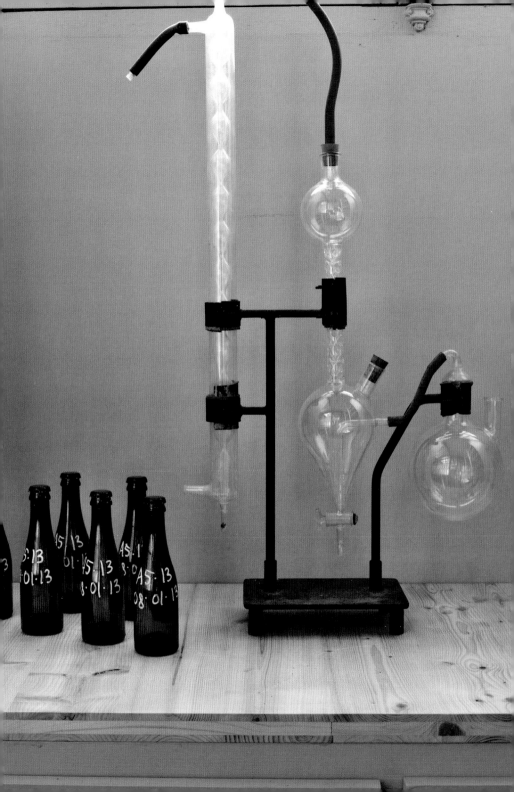

Three vintage Absinthe glasses and sample bottles used to ensure that, after a 95-year ban, when the first batch of Pernod Absinthe returned to the market in 2012 using the original recipe, it was perfect.

An absinthe pipe glass with built-in straw, designed to enjoy the 'Green Beast'. This original cocktail was created by Charles Vexenat to celebrate Pernod Absinthe's return to the market in 2012, nearly a century after the ban in 1915. It mixes Pernod Absinthe, simple syrup, lime juice, water and cucumber for an irresistible taste. In the background are sample bottles of the first batch of the 2012 production of Pernod Absinthe.

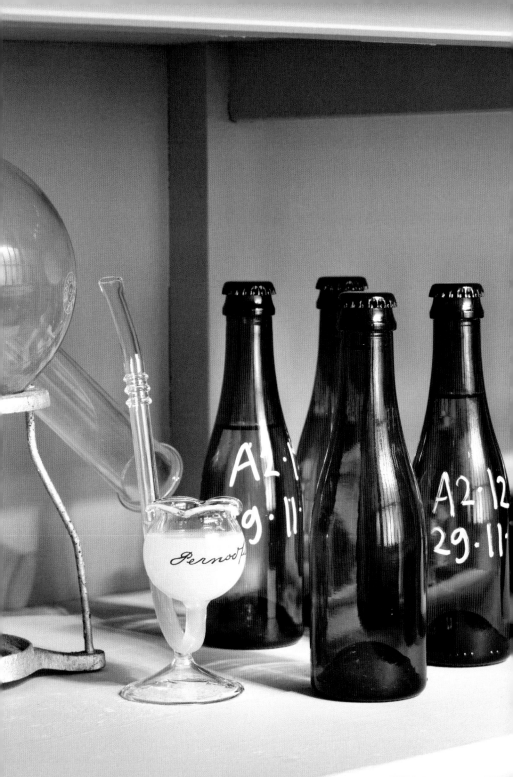

An antique, hand-blown Absinthe glass, complete with tin-plated Absinthe spoon and sugar cube, is ready for iced water to be added. The bubble in the glass contains exactly 2 cl of Absinthe and ensures a perfect measure without the use of a jigger.

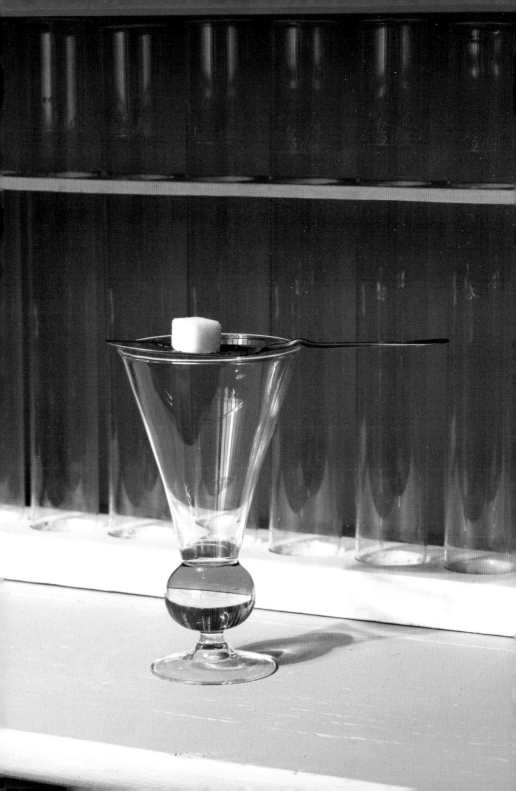

In a corner of the newly refurbished bar, beside a framed repro-
duction of Pablo Picasso's *Bouteille de Pernod et verre* (1912),
an original wooden spiral staircase winds its way up to the Mez-
zanine.

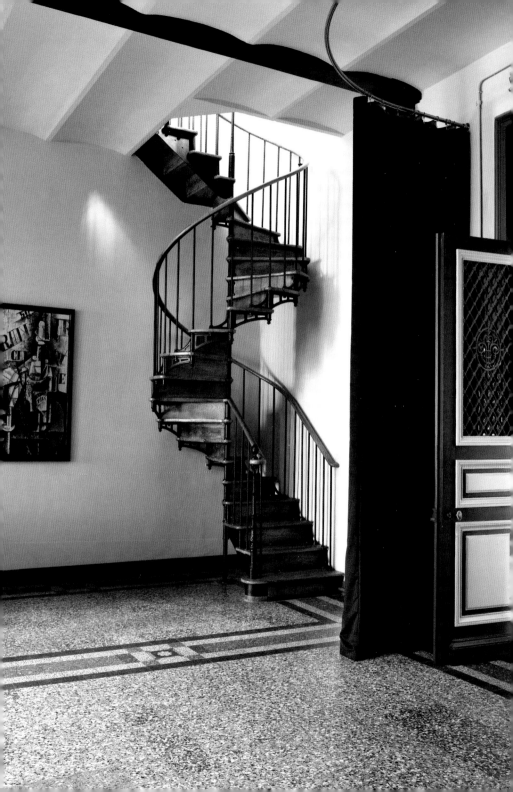

The perfect, U-shaped, stainless steel-topped bar, designed by Vaughan Yates and equipped by Eric Fossard in what was a typing pool in the 1950s, is situated directly beneath the balustraded central opening from the Mezzanine. It retains the spirit of a classical bar with shelves and fridges for up to 600 bottles on three sides, while the fourth side features a suspended signature wall displaying a collection of priceless vintage bottles and shakers.

The bar is used to welcome bartenders from all over the world and to introduce them to the secrets of the French apéritif, practising old and well-kept secrets, with the addition of a modern twist.

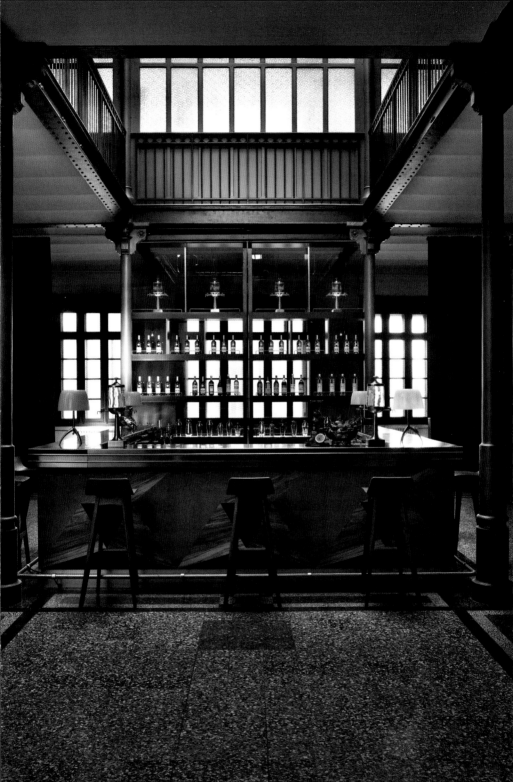

Assorted bottles of Pernod Absinthe are displayed on a shelf on the suspended signature wall behind the bar. In the centre is a British, silver-plated, 1920s 'teapot style' cocktail shaker from London-based wine and spirit merchants, Farrow & Jackson. The pouring spout is sealed with a cork stopper.

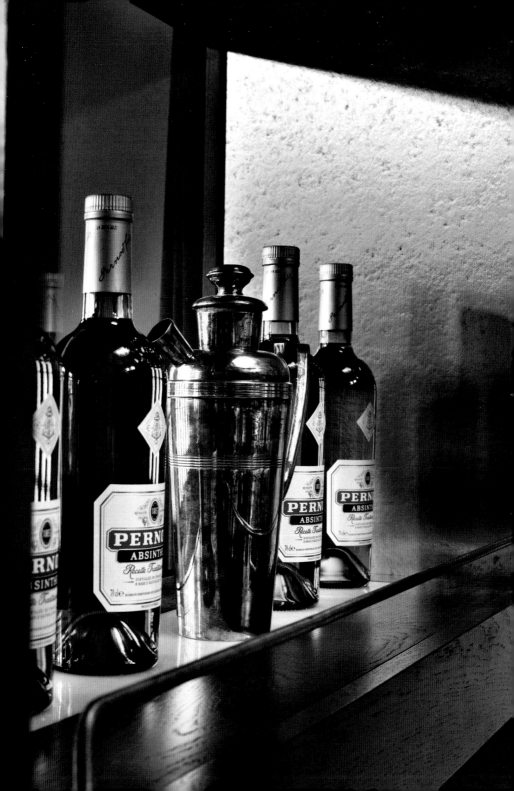

A 1920s Christofle spice ladle is displayed on a copper tray resting on a slowly melting lump of ice and decorated with a sprig of mint. The mint will be added to the silver mug at the last minute to ensure the freshness of this Ricard Julep: Ricard, sugar, water and fresh mint. Julep dates back to 1787 and was the preferred drink in the southern states of America. Julep is considered 'the big daddy' of all cocktails in general, and mojitos in particular!

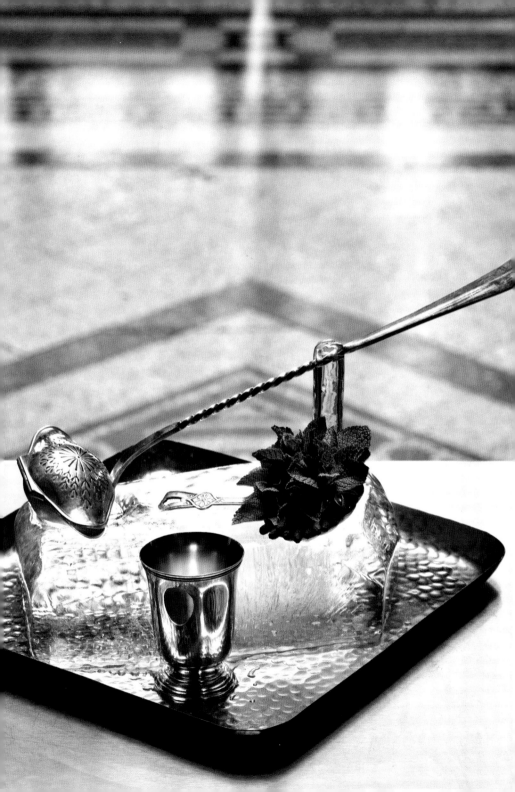

A Lillet Violet cocktail comprising measures of Lillet, Violet flowers and Violet liqueur. The secret recipe is held by Sasha Molodskikh, who runs the Parfum Bar in Montpellier, only 80 kilometers from Thuir. The cocktail is surrounded by a selection of shaker creativity from the 1930s: *(left)* a Danish Art Deco shaker from the Cohr Silver Company; *(centre)* a three-piece 'Cobbler' cocktail shaker with integrated strainer; *(right)* a French Saint Louis crystal and silver-plated evening cocktail shaker.

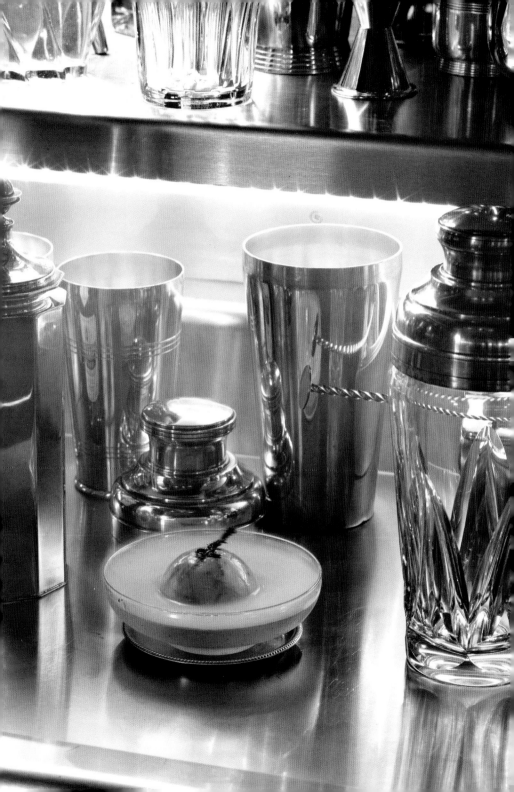

Pernod Absinthe and Corpse Reviver #Blue. This is a variation on Corpse Reviver No. 2 (gin + Lillet + Pernod Absinthe + Triple Sec + lemon) created in 1930 by the mythical Harry Craddock from the Savoy Cocktail Bar in London. Corpse Reviver, as the name suggests, was drunk as a 'hair of the dog' after a night of celebration. In the background is a British, silver-plated lemon squeezer dating from 1896, with an oak base on which are a few mandarins and a *cedrat.*

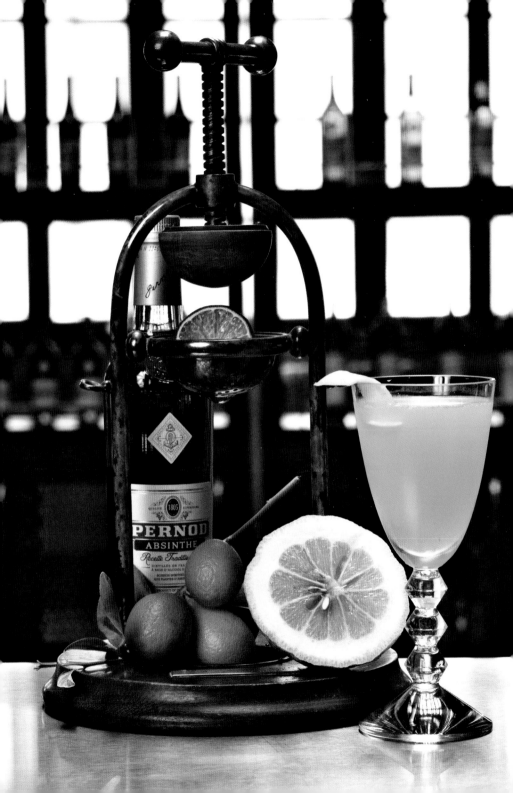

Absinthe paraphernalia from yesterday and today: *(from left to right)* a vintage hand-blown absinthe glass with absinthe spoon and sugar cube ready for absinthe and iced water to be poured; a classic silver-plated 30 ml and 45 ml French jigger used for measuring cocktails; a small stainless steel absinthe fountain dispensing iced water with a trace of cucumber to create a 'Green Beast' – such a small fountain is designed for table service for two, allowing iced water to drop over the sugar placed on the absinthe spoon and into the glass; an absinthe spray used to give that final exhilarating touch to a bitter cocktail. Cocktail aficionado C. F. Lawlor wrote in 1895 in his classic bartending book *The Mixicologist*: 'a dash or two of Absinthe would improve any cocktail'. The glass flask, called an *Absinthe Topette,* was once used for self-service at table: clients would have paid according to the number of rings of absinthe they would have served themselves.

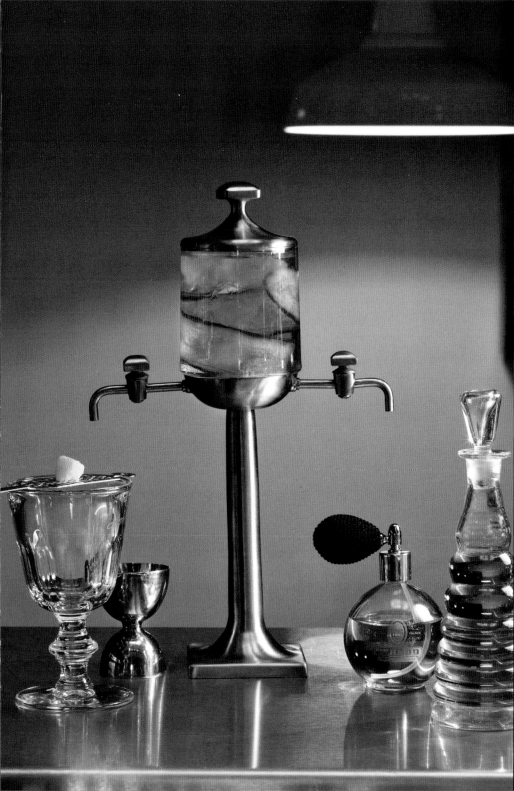

A silver-plated, Art Deco cocktail shaker with an integrated lemon juicer and a vintage copy of the legendary *Savoy Cocktail Book*, designed to collect and teach 'all that is known about cocktails' in 1930. The book catalogues more than 700 individual cocktail recipes, of which no less than 110 require absinthe. To this day, this book remains a valuable reference and continues to inspire a new generation of bartenders.

The Savoy Cocktail Book features five key reasons compiled by the English philosopher and theologian, Henry Aldrich (1647–1710) as to why men drink: 'good wine, a friend, or being dry, or lest we should be by and by, or any other reason why...'

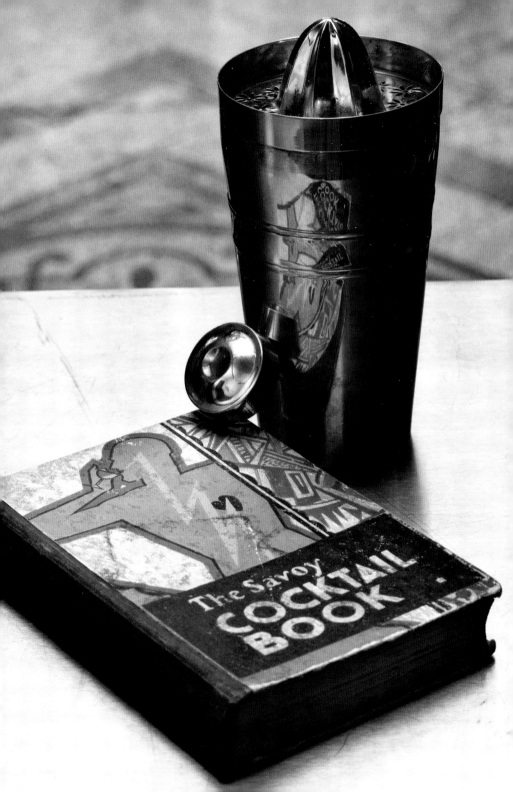

A bottle of Pernod Classic in the bar stands alongside a trio of collectors' items: two cocktail shakers of Danish design, one round with a Royal Danish Pattern from the 1950s, the other Art Deco and geometric in shape from the Cohr Silver Company; a British 'double tin' Farrow & Jackson cocktail shaker, and a British Sparklets soda siphon decorated in silver mesh.

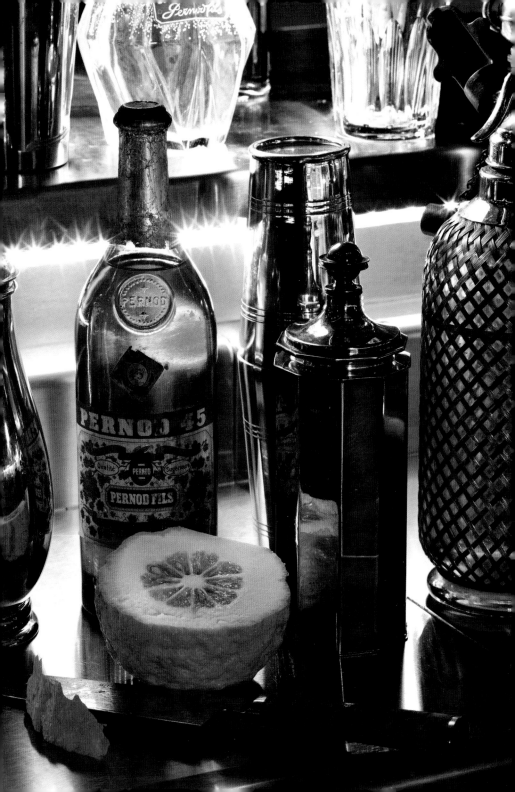

A visual guide to preparing and cutting crystal clear ice in the famous diamond-cut pattern. To cut the ice, a Japanese knife is the tool of choice. Japan has maintained the tradition of cutting ice blocks on the bar and produces the best blades for the job. Choose an ice machine, which freezes very slowly and involves a slight motion in the process, thus creating crystal ice. The slow movement prevents oxygen bubbles from being trapped in the ice and creates this fabulously transparent and clear result. You can now enjoy your Suze 'on the rocks', and what a rock! What a Suze!

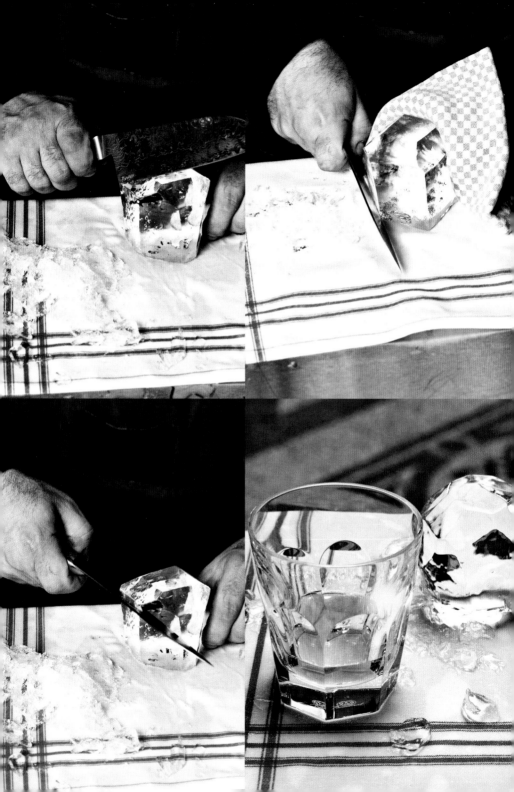

A row of Suze bottles on a shelf of the signature wall behind the bar is backlit by the evening light filtering through the window. Sunset means apéritif time … evening light means Suze time!

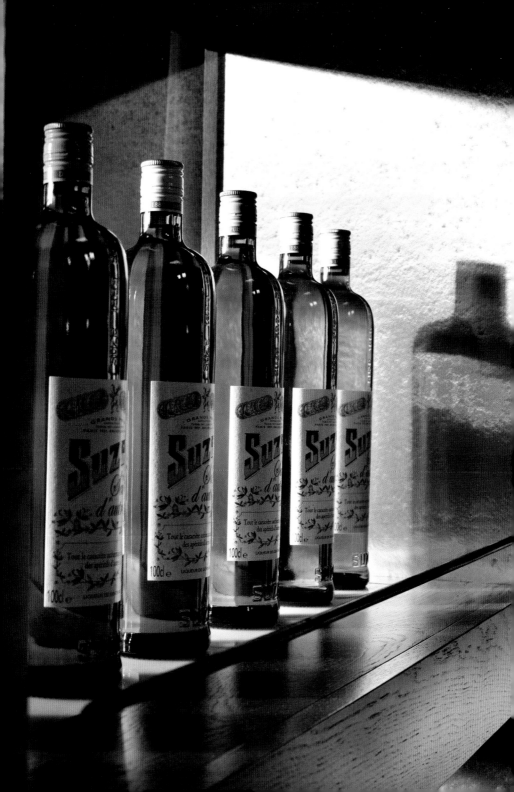

Suze Sour: Suze, lemon juice and syrup, with egg white to create a perfect foam on top. The cocktail is like a lemon meringue pie transformed into a drink. Beside the Suze bottle is a vintage British Sparklets soda siphon from the 1930s.

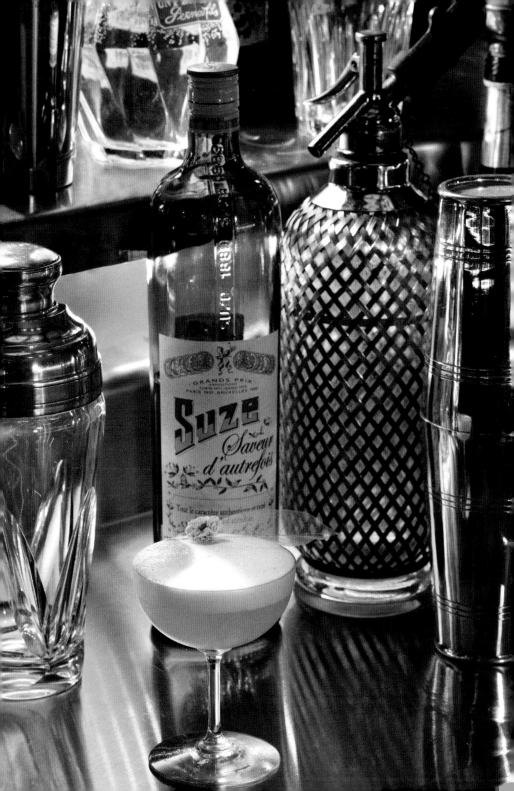

Bottles of Suze Saveur d'autrefois are interspersed with a French crystal and silver-plated evening cocktail shaker and a British Farrow & Jackson 'double tin' cocktail shaker from the 1930s.

The most famous Suze cocktail, the *fond de culotte* or Suze Cassis – no clear English translation, so let's call it Suze with blackcurrant. Measure 1/3 blackcurrant, 2/3 Suze – over ice or straight up. The sugar in the blackcurrant is a perfect balance to the bitter flavour of the Suze.

Suze Cassis is a perfect apéritif, its flavour enhanced by sardines in sunflower oil.

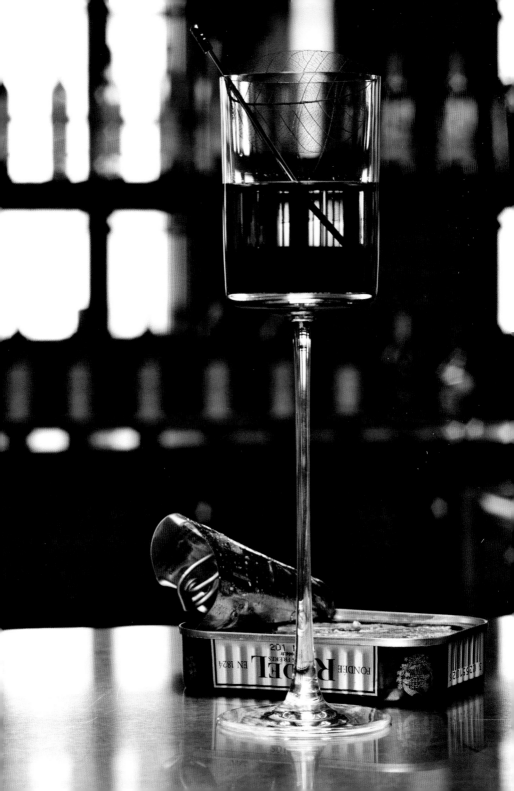

Ricard's main ingredient is star anise, a rare spice that grows near the southern Chinese border, with the addition of liquorice root and aromatic herbs. The quality and harmony of the ingredients are a reason for its success and unique flavour.

Ricard, celebrated as the quintessential drink of the South of France, is now enhanced by a variation of the quintessential drink of the American South and the official drink of the Kentucky Derby: the Mint Julep. In this case cognac is replaced by Pastis de Marseille. So let's welcome the Ricard Julep, first invented and served in 1954 by the head barman at the Hotel Crillon in Paris: a refreshing drink with fresh mint, Ricard, sugar over ice and served in a silver cup.

Such a simple drink is all you need to encourage conviviality amongst friends and to create the perfect *bar des amis*.

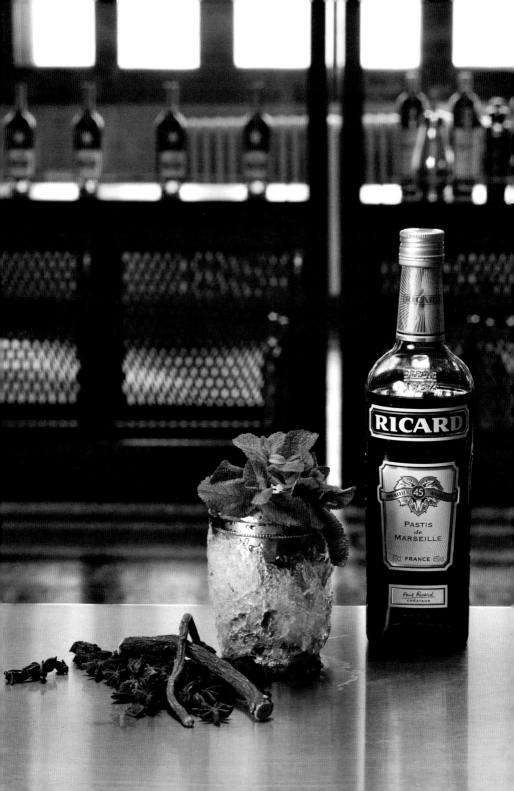

Lillet Blanc is the apéritif that best captures white wine elegance with a twist of bitter sweet and bitter orange. (*left*) The size of the ice cube in this coupe glass of Lillet 'on the rocks' emphasises the recommendation on the bottle to 'serve very cold'! (*right*) A Lillet Cup – a reinterpretation of a classic British herbal drink. Lillet, which already contains sweet and bitter orange, is infused with fresh fruit and herbs, such as kiwi, cucumber, mint, orange, thyme and star anise.

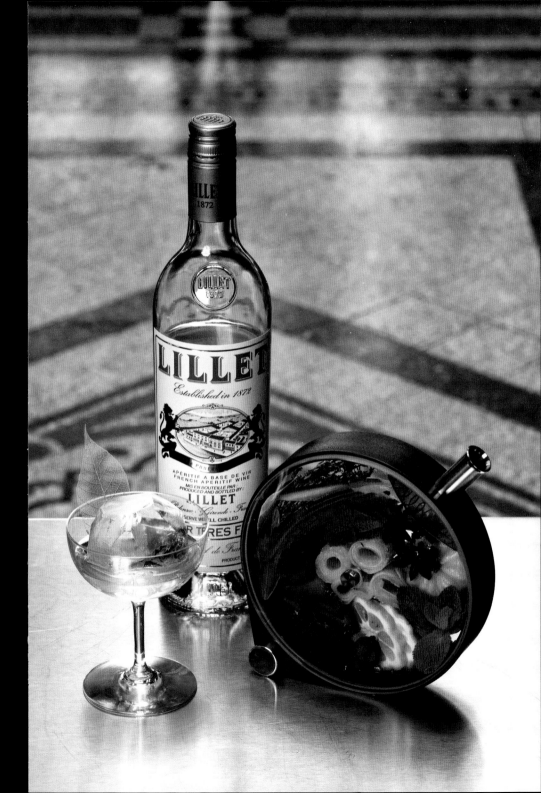

A Byrrh Stinger, an original recipe developed in 2007 by Julien Escot, a prominent French bartender, who revisited another classic cognac cocktail, is served on a bed of *Anis de Flavigny,* traditional mint pearls. Mint leaves are presented on a fine, late 19th-century, French silver strainer beside a slender Japanese muddler bar spoon, which is used to drop the anise pearls into the glass. The result emphasises all the aromas of spice present in the Byrrh: quinine, coffee, cocoa, elderflower and bitter orange dance on a bed of mints in your cocktail.

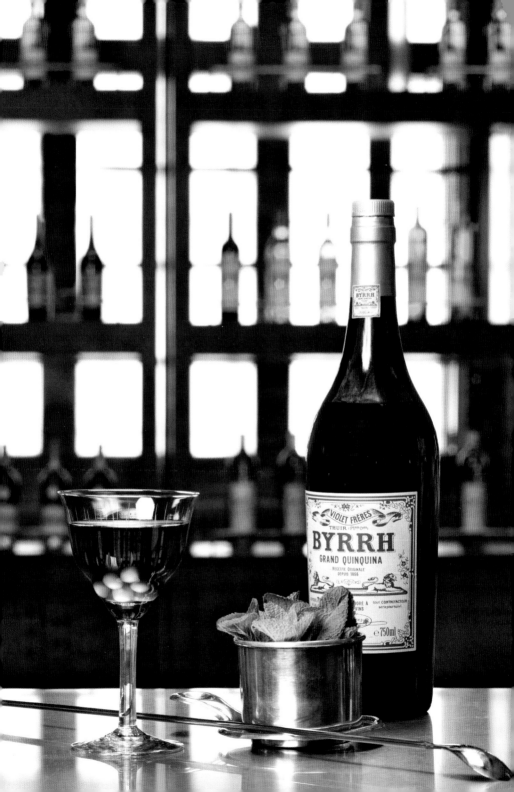

Mixologist Sasha Molodskikh prepares a Byrrh Stinger with traditional mint pearls. Sasha is one of the most creative of French bartenders, who dressed and prepared the selection of amazing cocktails for this book. He runs Le Parfum in Montpellier, less than an hour's drive from the Thuir distillery.

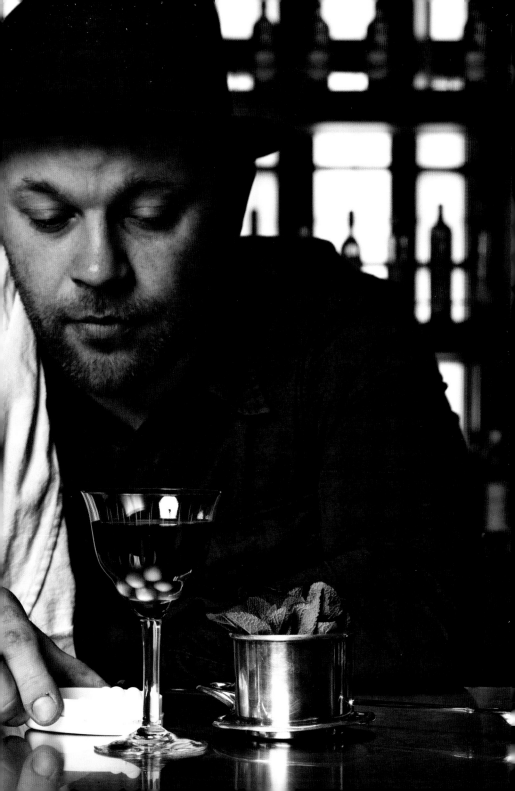

From left to right, variations on Ramos, a New Orleans Classic. In the centre, Ramos Gin Fizz, made of gin, lime, cream, egg white, lemon, sugar, orange flower and soda water. On the left, Blue Ramos, with a dash of Curacao. On the right, Red Ramos, with the addition of Byrrh. Accessorise with macaroons.

Red, white and blue – tradition, creativity and innovation: Do it the French Way!

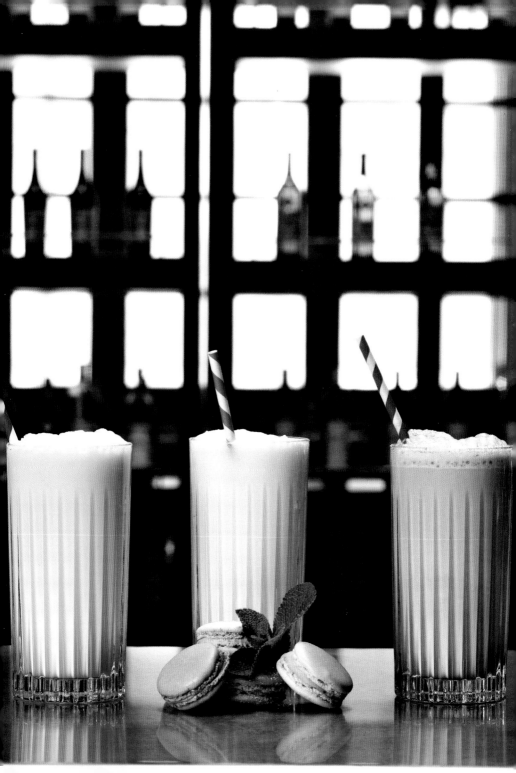

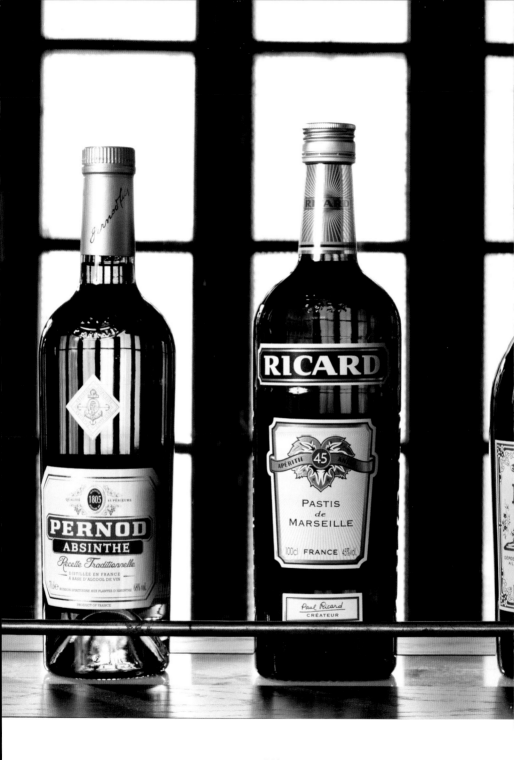

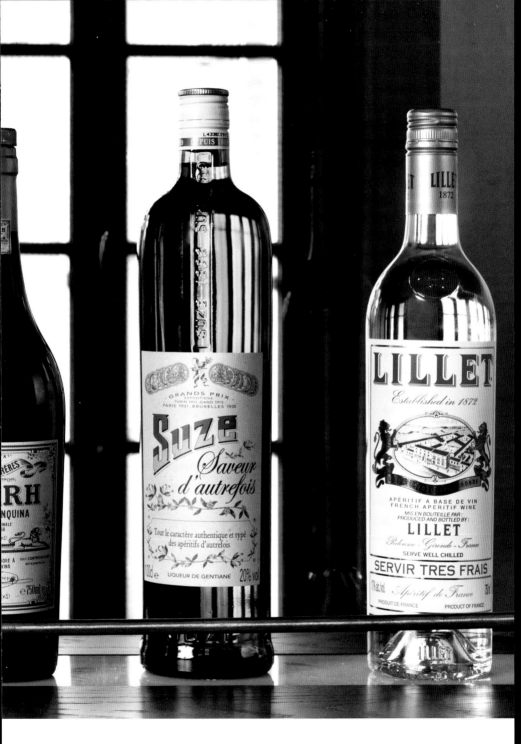

The magic five French Classics: Pernod, Ricard, Byrrh, Suze and Lillet – all number one bestsellers in the French market in their 20ᵗʰ-century heyday.

AROUND
THE WORLD

Amsterdam	Timo Janse from Door 74, Reguliersdwarsstraat 74I, Amsterdam, Netherlands
Athens	Vasilis Kyritsis from The Clumsies, Praxitelous 30, 105 61 Athens, Greece
Budapest	Zoltan Nagy from Boutiq'Bar, Paulay Ede u. 5, Budapest, Hungary
Copenhagen	Michael 'Gobo' Hansen from Ruby, Nybrogade 10, 1203 Copenhagen, Denmark
Hamburg	Jörg Meyer from Le Lion • Bar de Paris, Rathausstrasse 3, 20095 Hamburg, Germany
Havana	Alejandro Bolivar from El Floridita, Obispo No. 557, esq. a Monserrate, Havana 10100, Cuba
Hong Kong	Antonio Lai from Quinary, 56–58 Hollywood Rd, Central, Hong Kong, China
London	Xavier Padovani, Romée de Goriainoff, Olivier Bon, Pierre-Charles Cros from Joyeux Bordel, 147 Curtain Rd, London EC2A 3QE, UK
	Clotilde Lataille from Sardine, 15 Micawber St, London N1 7TB, UK
Lyon	Marc Bonneton from L'Antiquaire, 20 rue Hippolyte Flandrin, 69001 Lyon, France
Madrid	Diego Cabrera from Salmon Guru, Calle Echegaray 21, 28014 Madrid, Spain
Mexico	Jose Luis Leon from Licorería Limantour, Álvaro Obregón 106, Cuauhtémoc, Roma Nte., 06700 Mexico City, D.F., Mexico
Montpellier	Julien Escot from Papa Doble, 6 rue du Petit Scel, 34000 Montpellier, France
Montreal	Fabien Maillard from Lab Bar, 1351 Rachel St E, Montreal, Quebec H2J 2K2 Canada
Moscow	Slava Lankin from Delicatessen, Sadovaya-Karetnaya ul. 20, cpt. 2, Moscow, Russia
	Dimitry Sokolov from Mr Help & Friends, 1-ya Tverskaya-Yamskaya ul. 27, cpt. 1, Moscow 125047, Russia
Munich	Mauro Mahjoub from Mauro's Negroni Club, Kellerstrasse 32, 81667 Munich, Germany
New York	Naren Young from Dante, 79–81 Macdougal St, New York, NY 10012, USA
	Nico de Soto from Mace, 649 E 9th St, New York, NY 10009, USA
Paris	Rémy Savage from Little Red Door, 60 rue Charlot, 75003 Paris, France
	Carina Soto-Velasquez from Mary Celeste, 1 rue Commines, 75003 Paris, France
Shanghai	Sam Kuan from Barules, 51 Fenyang Road, Xuhui Qu, Shanghai, China
Stockholm	Patrik Tapper from Tjoget, Hornsbruksgatan 24, 117 34 Stockholm, Sweden
Tokyo	Hirosayu Kayama from Bar Benfiddich, Nishishinjuku, 1-13-7, 160-0023 Tokyo, Japan
	Rogerio Igarashi Vaz from Bar Trench, Ebisu-nishi 1-5-8 / 102, Shibuya-ku, Tokyo, Japan

THE TOOLS

1 The Cocktail Strainer Keeps ice in the shaker when straining a drink from the shaker to the glass.

2 The Jigger Each end of the jigger produces a precise yet different measure.

3 The Ice Pick Cuts and shapes pieces of ice from a block of ice.

4 The Cobbler Shaker Blends ingredients together and chills the drink filled with ice. The shaker comes in three parts.

5 The Doser Measures drops of concentrated ingredients, such as cocktail bitters.

6 The Bar Spoon Stirs the drink into the cocktail glass or mixing glass. Layers the drink when poured over the twisted stem of the spoon. Muddles mint leaves and sugar in the bottom of the glass.

7 The Julep Cup A metal cup used for Mint Juleps. Many other glasses are used for cocktails: old-fashioned, highball, coupe, champagne flute, Martini glass and more.

8 The Lemon Squeezer Squeezes the fresh juice from lemons and limes.

9 The Julep Strainer Keeps crushed ice in mixing glass when serving.

10 The Bitter Bottle Measures dashes of bitters.

11 The Mixing Glass Blends spirits together using a bar spoon over ice.

12 The Muddler. Muddles citrus wedges, fresh fruit and vegetables.

13 The Boston Shaker Blends any kind of ingredients together and chills the drink when filled with ice. The shaker comes in two parts.

14 The Nutmeg Grater Grates nutmeg on top of the drink – a very popular habit in the 19th century.

1

2

6

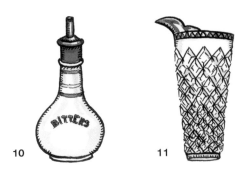

10

11

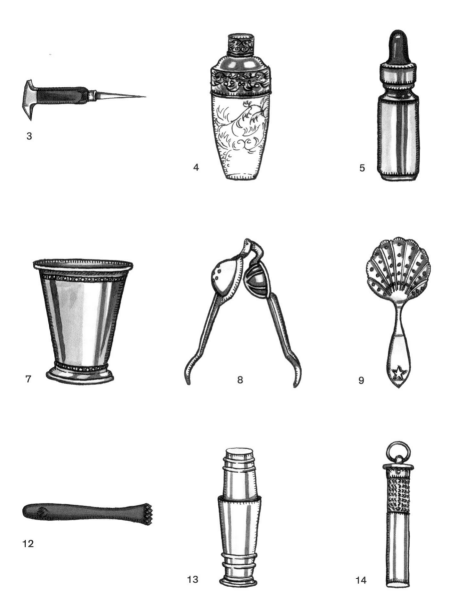

3

4

5

7

8

9

12

13

14

FIVE QUESTIONS FOR 25 OF THE WORLD'S BEST BARTENDERS

FIVE QUESTIONS FOR TIMO JANSE

The magic five French Classics: Pernod, Ricard, Byrrh, Suze and Lillet were all number one bestsellers in the French market in their 20ᵗʰ-century heyday. What importance do these French products represent for you in today's mixology?

These French Classics are 'must haves' in the bar. Pernod Absinthe, Ricard and Lillet are essential for making so many of the classic cocktails. Alternatively, Byrrh and Suze offer new and exciting ways to use two classic products, which are very welcome as well!

Imagine you had to create a bar just for your friends – what would it be like?

It would be a bar with an arcade, serving fresh food snacks, and since I consider so many of the great bartenders around the world to be my friends, it would need to have a back bar large enough to accommodate them all, where they can try out new flavours and engage in friendly rivalry!

Have you noticed a renaissance in the enjoyment of apéritifs in your city/country?

Absolutely! There are now many categories, such as vermouth, that are making a strong comeback as an apéritif in Amsterdam.

We would love to learn more about you, your work and your approach to mixology! What would you like to share with us about you and your bar?

Door 74 is a Prohibition-era bar, decorated in a 1920s Art Deco style, concealed behind an unmarked black-painted door. I've been the manager since it opened more than eight years ago, and my time here has been one great adventure. We pride ourselves on our cocktails and the quality of our drinks, for which we have earned a deserved reputation and which has led us to be cited in the World's 50 Best Bars list several times. Our bartenders regularly win cocktail competitions. We enjoy winning and we enjoy having fun!

Do you have a signature cocktail you would like to share with us?

TOUR DE FORCE

Shake well over ice and strain into a coupe glass.

30 ml Byrrh
30 ml Kever Genever
10 ml lemon juice
5 ml Pernod Absinthe

Garnish with lemon zest and mint leaves.

TOUR DE FORCE

Rub the mint in the palm of your hand before garnishing the cocktail. It will release a subtle mint aroma while drinking.

FIVE QUESTIONS FOR VASILIS KYRITSIS

The magic five French Classics: Pernod, Ricard, Byrrh, Suze and Lillet were all number one bestsellers in the French market in their 20ᵗʰ-century heyday. What importance do these French products represent for you in today's mixology?

The great thing with these products is that they are a link between the past and the future. Trends come and go but these French classics have been bartenders' favourite apéritifs for many years. What is important is that iconic products have become statements for the past, the present and the future.

Imagine you had to create a bar just for your friends – what would it be like?

It would be the most relaxed place, where my friends could have fun with the music, my drinks and above all enjoy themselves. The most important thing when creating your own bar is to make your guests feel at home.

Have you noticed a renaissance in the enjoyment of apéritifs in your city/country?

The apéritif is the next best thing in bartending. Today, people in Greece want to drink softer drinks with stronger tastes and apéritifs are the best spirits for this combination. Today I am inspired by the French apéritif. There is a combination of traditional French bartending (such as The Ritz in Paris) and modern concept bars using innovation (such as Candelaria or Little Red Door), so you can get inspiration from both the old and the new schools.

We would love to learn more about you, your work and your approach to mixology! What would you like to share with us about you and your bar?

I have been involved in the bar industry for the last eleven years and have worked at many bars and clubs during that time, before becoming the co-owner of The Clumsies two years ago. The Clumsies was shortlisted twice for 'Best New International Bar 2015' and 'Best High Volume Bar 2016' by Tales of the Cocktail, and has featured in the World's 50 Best Bars list twice in a row – so you could say I am more than happy! The Clumsies is an all-day bar located in the centre of Athens. It opens in the morning serving speciality coffee, followed later in the day by comfort food and apéritifs, with our signature cocktails available until late at night. The place is like a big house, so hospitality is the first thing that we really care about.

Do you have a signature cocktail you would like to share with us?

THE CLUMSIES SOUR

Shake well over ice and strain into a coupe glass.

35 ml Lillet Blanc
15 ml Suze
25 ml fresh lemon juice
15 ml homemade cucumber flower water
10 ml sugar syrup
30 ml egg white

Garnish with lemon zest.

THE CLUMSIES SOUR

Ensure you fill your cocktail shaker with ice and shake until the outside is well and truly frosted. Your cocktail will be colder and taste better as a result.

FIVE QUESTIONS FOR ZOLTAN NAGY

The magic five French Classics: Pernod, Ricard, Byrrh, Suze and Lillet were all number one bestsellers in the French market in their 20th-century heyday. What importance do these French products represent for you in today's mixology?

These are products of a quality which has been refined over 200 years. It's just a shame that here in Hungary they are sometimes difficult for bartenders to get hold of. France has a completely different way of making drinks when compared to the monster markets of the USA and UK. It's qualitative, funky and stylish and has a sparkle we have lost. I am happy that the French are very stubborn about quality – I think we should be too!

Imagine you had to create a bar just for your friends – what would it be like?

If it was just for friends then money wouldn't matter and it would resemble a huge kitchen, because the more accessible the bar is, the better. It would be spacious, with very comfortable chairs, nice music, a huge centrepiece bar, lots of texture and mainly natural light.

Have you noticed a renaissance in the enjoyment of apéritifs in your city/country?

Not yet. In Hungary, we have a combination of tourists and locals who tend to be conservative in their taste. At my bar we are introducing a couple of quality drinks – apéritif cocktails, as well as low alcohol cocktails – and they're doing quite well. But this is the exception rather than the rule of what's happening here in Budapest. In a lot of bars cocktails are about disguising the flavour of alcohol, instead of enhancing it.

We would love to learn more about you, your work and your approach to mixology! What would you like to share with us about you and your bar?

My bar opened nearly nine years ago. At the beginning, I was very keen on making amazing drinks and I am still trying to make amazing drinks but, over the years, I have come to understand that the drink only contributes 10% to the overall experience. It's all about the bar! We pay great attention to the training of our staff and, while we understand that we're not superstars, just people serving other people, we like to ensure this is done with care and the highest attention to detail. Our bar was revolutionary in Budapest and I see a lot of people are following what we're doing, so I'm very happy with our work!

Do you have a signature cocktail you would like to share with us?

KILL OR BYRRH

Pour over ice into an old-fashioned glass. Stir well.

60 ml Byrrh
20 ml Branca Menta

Garnish with orange zest.

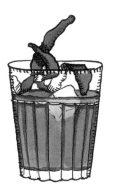

Even an easy cocktail made with ingredients with a strong flavour requires the use of a jigger. Consistency is key in mixology.

RUBY

NYBROGADE

№ 10

RUBY
Nybrogade 10
1203 København K, Denmark
www.rby.dk

FIVE QUESTIONS FOR MICHAEL 'GOBO' HANSEN

The magic five French Classics: Pernod, Ricard, Byrrh, Suze and Lillet were all number one bestsellers in the French market in their 20th-century heyday. What importance do these French products represent for you in today's mixology?

They play a big part today in a bartender's work and so they should, since they are classic products that all bars should have. However, they don't yet play as big a part in modern cocktails, so we need to get the message out. In Copenhagen, the good news is that apéritif cocktails are becoming trendy. My favourite at the moment is the Suze Tonic. It's simple it's easy, it's refreshing, it's bitter.

Imagine you had to create a bar just for your friends – what would it be like?

Fun is the key word. My menu would be simple, so it appeals to my friends, who are not bartenders. Three or four ingredients, fresh products and twelve to 15 cocktails. The music should set the tone, and the bartenders should make a great, happy team. The staff makes a place. It wouldn't be a party bar, but a place you'd be excited to go to. We would seat 30 to 40 people. Ideally, I'd have a kitchen serving small, sharing plates. It's also very important that you can come to a bar on your own, have a great time, and feel you are part of something bigger.

Have you noticed a renaissance in the enjoyment of apéritifs in your city/country?

We're seeing more requests for apéritifs, especially Lillet and Suze, and there's more awareness of what these are. Bartenders are using them more, but only the top cocktail bars really know about them, so there's still a long way to go, especially to get restaurants on board. The Danes don't have a tradition of going out during the week, but we're moving in the right direction.

We would love to learn more about you, your work and your approach to mixology! What would you like to share with us about you and your bar?

I work at Ruby, Lidkoeb and Brønnum, three bars owned by the same couple, and Ruby is the most famous – one of the World's 50 Best Bars. I assist and support the bar manager and general manager of each bar and have been a sort of brand ambassador for the last five years. The most important thing about bartending is the personality you bring to the job. People don't come to our bars just for the drink, but also for the service they get.

Do you have a signature cocktail you would like to share with us?

WET RUBY MARTINI

Stir well over ice in a mixing glass and strain in a coupe glass.

50 ml gin
15 ml Lillet Blanc

Garnish with a grapefruit rind.

Dilution is key with this kind of dry cocktail, so make sure you chill the mixing glass by first stirring the ice on its own. Strain any remaining water before adding the ingredients.

FIVE QUESTIONS FOR JÖRG MEYER

The magic five French Classics: Pernod, Ricard, Byrrh, Suze and Lillet were all number one bestsellers in the French market in their 20ᵗʰ-century heyday. What importance do these French products represent for you in today's mixology?

We use Lillet a lot. Lillet Blanc is the house drink of Le Lion • Bar de Paris and Lillet Rosé with tonic is a very strong highball served at the Boilerman Bar. Suze is a very fine product, which we use for rare classics. Pernod Absinthe is a fine spice for some classics like Sazerac and Morning Glory Fizz. Byrrh and Ricard are not stocked in our bars yet, but I love them both.

Imagine you had to create a bar just for your friends – what would it be like?

I don't really believe in a friendship bar. A bar for me should be a magic place and there needs to be a fine line drawn between the people serving and the people drinking. Going to a bar is like going to a show at night. As far as I am concerned, I could not create a bar for my friends, because in a bar you need distance. For friends, a chilled glass of fortified wine is sometimes all it takes to be in fine company. For guests we have to set up a stage each night!

Have you noticed a renaissance in the enjoyment of apéritifs in your city/country?

Yes! We have quite a demand at our Boilerman Bar and at Le Lion • Bar de Paris. For me it is really up to the individual bar. If they want a renaissance in the apéritif, they can really make it happen. At the Boilerman Bar we feature the #DayDrinking, to play with the idea that it is better for you to start drinking at three or four in the afternoon, than at night. And there is still work to be done. Some people are afraid of fortified wines, because they have no idea of their diversity nor of the taste.

We would love to learn more about you, your work and your approach to mixology! What would you like to share with us about you and your bar?

Le Lion • Bar de Paris is a classic bar serving a short selection of classic cocktails and champagne each night. The Boilerman Bar is a neighbourhood bar, serving quick and easy highballs, along with good music.

Do you have a signature cocktail you would like to share with us?

LE COQUETIEZ DU LION

Stir well over ice in a mixing glass and strain in a coupe glass.

50 ml Lillet Blanc
30 ml gin
3 dashes of Peychaud bitters

Garnish with lime zest.

This has been the house drink of Le Lion • Bar de Paris since we opened nine years ago. The wrong spelling is a tribute to the 'Martinez' Cocktail!

LE COQUETIEZ DU LION

Follow the recipe carefully when adding cocktail bitters as they are very concentrated.

EL FLORIDITA
Obispo No. 557 esq. a Monserrate, Havana 10100, Cuba
www.floridita-cuba.com

Floridita

FIVE QUESTIONS FOR ALEJANDRO BOLIVAR

The magic five French Classics: Pernod, Ricard, Byrrh, Suze and Lillet were all number one bestsellers in the French market in their 20ᵗʰ-century heyday. What importance do these French products represent for you in today's mixology?

In Cuba, the best-known French apéritifs are Ricard and Pernod. Lillet Blanc was introduced more recently, while Pernod Absinthe should be used in small quantities to enable the Cuban public to better identify its different flavours in cocktails and get used to its taste. It's the same with cigars: start first with a light one and then go on to stronger ones. I heard that before the Revolution we used to make a daiquiri at El Floridita with absinthe called 'Greta Garbo' – it would be a great idea to bring it back again!

Imagine you had to create a bar just for your friends – what would it be like?

I have travelled a lot and have got to know bars all over the world. For me, El Floridita is the best. If I had to build a bar for my friends, it would be small, well-designed, with live music, comfortable seating and room to dance. Since Cuban culture is synonymous with cigars, my bar would need to include a small smoking area. The interior of the bar would be like the El Floridita, which dates from the 1800s. The secret of a good cantinero is to make sure clients become friends.

Have you noticed a renaissance in the enjoyment of apéritifs in your city/country?

Cuba is a very particular country, unlike any other. A lot of products have disappeared, which has certainly had an impact on what cantineros can prepare. Since the 1990s however, tourists have returned and we have started making Dry Martini, Negroni, Americano and Pernod cocktails again. Now, since the visit of President Obama and with the end of the US embargo in sight, things are changing. I foresee a development in the creation of new cocktails, just as we experienced here in Cuba in the 1920s.

We would love to learn more about you, your work and your approach to mixology! What would you like to share with us about you and your bar?

I became a bartender in the early 1990s when Cuba opened to tourism. I worked in hotels and cabarets until 1998 when I replaced a retired cantinero at El Floridita. I've worked here ever since, as well as travelling a lot to promote El Floridita and Cuban cocktails. If my health allows, I will retire at El Floridita. This place makes me happy.

Do you have a signature cocktail you would like to share with us?

HAVANA NIGHT

Pour over ice into a highball glass. Stir well.

2 dashes of aromatic bitters
5 ml Pernod Absinthe
60 ml Havana Club seven-year old

Top up with lemon-lime soda and garnish with orange peel.

136

HAVANA NIGHT

Absinthe has a strong fla-
vour so be sure to measure
the quantity you add to the
cocktail using a bar spoon.

FIVE QUESTIONS FOR ANTONIO LAI

The magic five French Classics: Pernod, Ricard, Byrrh, Suze and Lillet were all number one bestsellers in the French market in their 20ʰ-century heyday. What importance do these French products represent for you in today's mixology?

Pernod Absinthe is very important for us, as more and more people are enjoying absinthe these days in Hong Kong. Lillet has been around for a while and has become increasingly popular with the Vesper, and it makes a nice apéritif drink too. Most importantly, we have a lot of French people working here, so the French Classics not only help to quench their thirst but also provide solace when they are a little homesick!

Imagine you had to create a bar just for your friends – what would it be like?

It would be a very advanced cocktail bar full of cool equipment, such as a rotary evaporator, Perlini shaker, sonic prep, sous-vide, vacuum machine etc., so together we can create 'crazy' drinks and non-alcoholic cocktails, with no need for a menu.

Have you noticed a renaissance in the enjoyment of apéritifs in your city/country?

Yes, people like to go drinking before partying and also to go out after dinner.

We would love to learn more about you, your work and your approach to mixology! What would you like to share with us about you and your bar?

Taking a lead from the inventive approach to food pioneered by the likes of Ferran Adrià Acosta at his El Bulli restaurant, Quinary brings to cocktails this same food-science approach that understands why certain aromas, flavours and textures work together and seeks to engage all five senses. I am the Diageo World Class 2015 Hong Kong and Macau Champion, so expect the unexpected! Combinations of flavour and aroma, together with different textures, appearances and even sounds, will challenge every preconception held about cocktails. Where classics take on a new twist, where new drinks may become tomorrow's classics, Quinary will take you on a multi-sensory experience into the new world of cocktails.

The long bar extends to my lab, showcasing the rotary evaporator, where we re-distil our own wasabi vodka for the Quinary Bloody Mary; the centrifuge, creating a cleaner, crisp grapefruit juice for our Crystal 24 cocktail; and the caviar box for my signature Earl Grey Caviar Martini.

Do you have a signature cocktail you would like to share with us?

ABSINTHE PALOMA

In a highball glass, muddle the grapefruit, add mint and fill the glass with crushed ice. Complete with the other ingredients and stir well.

45 ml Pernod Absinthe
2 fresh grapefruit wedges
6–8 fresh mint leaves
Top up with grapefruit soda
3 drops of Suze Bitters Aromatic

Garnish with a grapefruit wheel and a sprig of mint sprinkled with powdered sugar.

ABSINTHE PALOMA

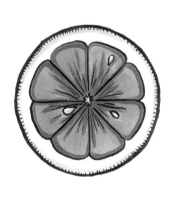
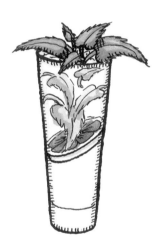

Rub the mint between your fingers before garnishing the cocktail. It will release a subtle mint aroma while drinking.

JOYEUX BORDEL
147 Curtain Rd
London EC2A 3QE, UK
www.joyeuxbordel.com

FIVE QUESTIONS FOR XAVIER PADOVANI, ROMÉE DE GORIAINOFF, OLIVIER BON AND PIERRE-CHARLES CROS

The magic five French Classics: Pernod, Ricard, Byrrh, Suze and Lillet were all number one bestsellers in the French market in their 20ᵗʰ-century heyday. What importance do these French products represent for you in today's mixology?

These products are part of our French drinking history. They are omnipresent in our bars. They stand strong and play their part in many classic recipes. Added to this is the fact that, as French nationals, we will always have a soft spot for our national heritage and stand prepared to represent, in an organic way of course, our country's historical liquid assets!

Imagine you had to create a bar just for your friends – what would it be like?

Easy! It's called Experimental Beach in Ibiza. A beach bar with an amazing view, a good team of bartenders mixing a few simple drinks, some ice-chilled champagne and a house at the back to welcome all friends – the perfect *bar des amis* ['bar for friends']!

Have you noticed a renaissance in the enjoyment of apéritifs in your city/country?

In London, French apéritifs have always been popular. But in recent years, low alcohol ingredients, such as apéritifs, have gone through a resurgence – they are becoming more and more popular and now feature in many cocktail recipes across London.

We would love to learn more about you, your work and your approach to mixology! What would you like to share with us about you and your bar?

I am guessing you are quite familiar with our approach and our bars in London. They are cosy. One, the Experimental Cocktail Club, is

concealed behind an anonymous door in the middle of Chinatown and the other, Joyeux Bordel, is in a basement in Shoreditch. At Joyeux Bordel we offer a very simple cocktail list, consisting of ten to twelve of the best cocktails, a decent selection of vintage spirits, an exciting range of vermouth and a few boilermakers. There is also good music, with a live DJ most days, and good, simple drinks in a relaxed atmosphere.

Do you have a signature cocktail you would like to share with us?

GET BUCK IN HERE

Shake well with ice and strain into a highball glass over ice.

25 ml Suze
25 ml gin
10 ml lemon juice
6 dashes of Pernod Absinthe

Top with ginger ale and garnish with grapefruit peel.

When you shake the ingredients, don't include anything fizzy so, in this case, add the ginger ale once the contents of the shaker have been strained into the glass.

SARDINE

FIVE QUESTIONS FOR CLOTILDE LATAILLE

The magic five French Classics: Pernod, Ricard, Byrrh, Suze and Lillet were all number one bestsellers in the French market in their 20ᵗʰ-century heyday. What importance do these French products represent for you in today's mixology?

The French Classic products represent a cultural legacy and a history in today's mixology. They are present in the very first cocktail book, essential ingredients, a bit like butter in a cookery book. For me, they also represent inspiration and challenge. Our palate has changed over the centuries, as architecture and art has before us. The beauty of the apéritif is the connection between historical roots and modernity.

Imagine you had to create a bar just for your friends – what would it be like?

It would be a big, cosy living room, with comfy Chesterfield sofas, a communal wooden table, and a wall filled with all manner of books. The bar would be in the middle of the room and everybody would be able to go behind it, to create and to be host for an evening. It would be a basement and attached to the living room would be a small cinema, with a sunny garden beyond – a bit like Claude Monet's garden at Giverny. Next to it would be a creative room, a kind of boudoir, where we could create, experiment and share new, homemade ingredients.

Have you noticed a renaissance in the enjoyment of apéritifs in your city/country?

Of course! Apéritif is the new black. Low ABV cocktails are everywhere. Bitterness is fashionable. Look at the number of new bitters and fortified wines on the market these past five years. This a great reflection of what's going on and a sure sign of the new trends.

We would love to learn more about you, your work and your approach to mixology! What would you like to share with us about you and your bar?

Born and raised in France, I chose London as my adopted city after spending a few years in Switzerland, graduating in fine art. I fell in love with the industry four years ago when cutting my teeth at the Callooh Callay Bar in Shoreditch. I like to combine art and cocktails. 'A blank canvas is like an empty glass.' I recently joined Alex Jackson, head-chef and owner of Sardine, to become the lady behind the bar. For me, mixology represents self-expression and an opportunity to create, deliver and share an experience with my guests. When I was setting up the bar at Sardine before the opening, I spent quite a lot of time with Alex, listening to him and understanding his way of cooking. As a result, I decided to focus on the apéritif. The back bar has only one bottle of each spirit; the rest are apéritifs. The list at Sardine is short, six cocktails, simple and served at reasonable prices. I wanted to disconnect with the image of a cocktail that can be both expensive and complicated.

Do you have a signature cocktail you would like to share with us?

BOTTLE AND GLASS

This cocktail was inspired by Picasso's painting *Verre et bouteille de Suze* (1912). Mix everything, except the Suze, in a small bottle. Pour the measure of Suze into a wine glass and use the bottle as a mixer. Mix as you wish, all together, or little by little. The perfect refreshment to enjoy in the sun with some friends.

35 ml Suze Saveur d'autrefois
15 ml verjuice
2.5 ml passion fruit syrup
90 ml of cold lemon verbena tea

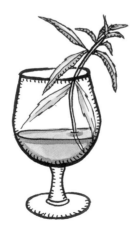

Don't hesitate to experiment with different amounts of lemon verbena in your tea to vary the flavour of the cocktail.

FIVE QUESTIONS FOR MARC BONNETON

The magic five French Classics: Pernod, Ricard, Byrrh, Suze and Lillet were all number one bestsellers in the French market in their 20ᵗʰ-century heyday. What importance do these French products represent for you in today's mixology?

These products are important because they are part of our roots; they define what kind of drinks we like and therefore what kind of drink we are going to create. For example, Italian bartenders are more likely to create a bitter cocktail, an aperitivo cocktail, because they are surrounded by amaro, bitters. We, the French, go more for 'wine' cocktails because of Byrrh and Lillet, or something flavoured with anise because of Ricard and Pernod Absinthe.

Imagine you had to create a bar just for your friends – what would it be like?

This is a good question! What drink would a bartender serve if he didn't have to worry about profit and money! It would it be a Van Winkle old-fashioned; a Louis XIII sour; a champagne cocktail with Krug; highest quality organic fruit, perfect ice from Clinebell, luxury crystalware that you are not worried about breaking… For me, the perfect bar would be one in which I am able to serve the best drinks, with the best staff, with live jazz, smoking the best cigars, eating top finger food and all in the best company!

Have you noticed a renaissance in the enjoyment of apéritifs in your city/country?

Yes, I have noticed a kind of renaissance with Spritz, Americano and Negronis – more aperitivo in fact. Customers don't yet spontaneously order a neat Suze or Byrrh, but when cocktails are nicely done, they are universally enjoyed. So we serve Byrrh in Byrrh 'n' Stormy, and Suze in Suzzle (Suze, lemon, vanilla sugar, crème de mure) served with a twist of bramble.

We would love to learn more about you, your work and your approach to mixology! What would you like to share with us about you and your bar?

My bar, L'Antiquaire, is the home of classic cocktails, served with the house twist. We reinvent the classics by introducing a new and original approach, the result of twelve years of travelling and my experience visiting some of the best bars in the world. I want to offer my guests the ultimate cocktail experience, drawing on all the little details I brought back with me from my travels. Today we use homemade syrups, preps, batches and infusions combined in a service ritual and we continue to learn and reinvent everyday.

Do you have a signature cocktail you would like to share with us?

BYRRH 'N' STORMY

One of the best sellers in wintertime. Pour over ice into a highball glass. Stir well.

45 ml Byrrh
15 ml Martell VSOP cognac
20 ml lime juice
Dash Suze Bitters Aromatic

Top up 1/2 soda water, 1/2 ginger beer, and garnish with a wedge of lime.

BYRRH 'N' STORMY

 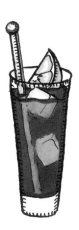

To achieve the perfect balance, make sure you use a jigger. This will ensure that your cocktail has a consistent taste throughout.

SALMON GURU

FIVE QUESTIONS FOR DIEGO CABRERA

The magic five French Classics: Pernod, Ricard, Byrrh, Suze and Lillet were all number one bestsellers in the French market in their 20ᵗʰ-century heyday. What importance do these French products represent for you in today's mixology?

We live in a time of expansion and growth in mixology. It's one of the most creative moments we've ever known. In this constant search for things that help to set us apart, new products are released almost every week, but we can also rely on products that have always been with us, ones that our ancestors would have drunk, and so it's important to look back at the past. Today, when we use them to create a new cocktail, we feel sophisticated, and even more so when we read the label and realise that most of the references are French.

Imagine you had to create a bar just for your friends – what would it be like?

My good fortune is that this dream has already become a reality! In my bar, I never lack friends – wide smiles, good music to liven up the mood, fun conversation – topped by the desire for everyone to share in the best Argentine mate ritual: a cocktail made by me, of course!

Have you noticed a renaissance in the enjoyment of apéritifs in your city/country?

No one escapes the boom of the apéritif. Wherever I go, I am ready to make a good apéritif cocktail or mix apéritif with seltzer. People gather for apéritifs and everyone is interested – my bar is no exception.

We would love to learn more about you, your work and your approach to mixology! What would you like to share with us about you and your bar?

I fell into this industry by chance when I started working in a bar at weekends while study-ing international trade. I was lucky. There were great professionals in that bar, so knowledge and passion came guaranteed. After university I took a sabbatical and realised that I could work as a bartender anywhere in the world … and I have never stopped. Today, I have been fortunate enough to open my most entertaining and personal of projects. Salmon Guru is a bar with five themed sub-spaces dedicated to classic cocktails: innovation, the culture of spirits, intimacy, research and development. The name is about going against the flow, pursuing your own direction, influenced by knowledge and wisdom. Salmon Guru is a place designed for enjoyment.

Do you have a signature cocktail you would like to share with us?

MESTIZO

Rinse an old-fashioned glass with Ricard, then pour the ingredients over ice. Stir well.

5 ml Ricard (for rinsing the glass)
30 ml Lillet Blanc
30 ml Mezcal
30 ml Aperol

Add a splash of cardamon tonic water, and garnish with thin zests of grapefruit, lemon and lime.

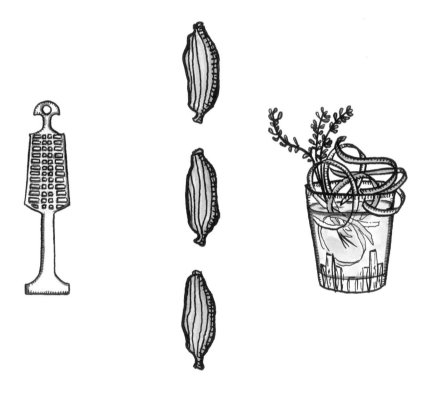

Rinse the glass with the aromatic products, which give a subtle flavour to the cocktail. Then, fill the glass with crushed ice and add the Ricard; by doing so you will not only chill the glass but coat the surface with Ricard at the same time.

FIVE QUESTIONS FOR JOSE LUIS LEON

The magic five French Classics: Pernod, Ricard, Byrrh, Suze and Lillet were all number one bestsellers in the French market in their 20ᵗʰ-century heyday. What importance do these French products represent for you in today's mixology?

Unfortunately we do not have all these brands in Mexico, just Pernod (without the absinthe), Ricard and Lillet but, with the development of cocktail culture, we are starting to use these products more and more, especially Lillet. At Baltra, 80% of our cocktail menu is based on apéritifs. This is important because apéritifs have a unique complexity of flavours and, using only a few ingredients, we can create a balanced cocktail that consumers greatly enjoy.

Imagine you had to create a bar just for your friends – what would it be like?

Following on from the success of Licorería Limantour, Baltra, the second of our bars, is just that – a bar created for friends. Baltra is an intimate, cosy place, where we offer customers and friends a variety of our favourite spirits and cocktails.

Have you noticed a renaissance in the enjoyment of apéritifs in your city/country?

Yes, there is a renaissance, because bartenders are looking for new products that will afford the customer new flavours. We offer apéritifs at Baltra because these brands have a great history and tradition, and an extra element that our customers really appreciate.

We would love to learn more about you, your work and your approach to mixology! What would you like to share with us about you and your bar?

I am the bar manager of the Grupo Sicario, which, among other companies, owns Licorería Limantour (rated No. 20 in the World's 50 Best

Bars) and Baltra, both cocktail bars in Mexico City. Licorería Limantour was the spearhead of our country's cocktail scene. From the start we wanted honest cocktails and, while influenced by both European and American recipes, we have always created cocktails that come from the heart. Baltra was born from a desire to create a more personal place, very different from Limantour.

Do you have a signature cocktail you would like to share with us?

OLD GEORGE SOUR

Shake well over ice and strain into a coupe glass.

30 ml Pernod Absinthe
30 ml Tequila Altos Blanco
25 ml cucumber syrup
30 ml lime juice
15 ml egg white
2 fresh basil leaves
1 cardamon seed

Garnish with pollen and cardamon.

OLD GEORGE SOUR

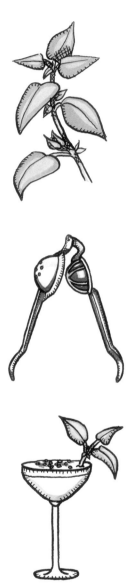

Don't muddle the basil leaves; contact with the ice in the cocktail shaker is enough to extract the flavour.

PAPA DOBLE
6 rue du Petit Scel, 34000 Montpellier, France
www.papadoble.fr

FIVE QUESTIONS FOR JULIEN ESCOT

The magic five French Classics: Pernod, Ricard, Byrrh, Suze and Lillet were all number one bestsellers in the French market in their 20th-century heyday. What importance do these French products represent for you in today's mixology?

These products are coming back hot on the heels of the cocktail renaissance. Bartenders want to rediscover the vintage classics and forgotten cocktails. It is totally natural to see new life breathed into Pernod Absinthe and the return of these great apéritifs. With the evolution in mixology, we can now imagine new creations for each of them.

Imagine you had to create a bar just for your friends – what would it be like?

I would go for simple drinks made with great spirits, apéritifs and liqueurs. I would have a turntable with a great selection of vinyl discs: classics from the '70s, '80s and '90s. My friends would choose the mood to suit the evening. I would have a warm design with a Provençal touch, because I come from the South of France.

Have you noticed a renaissance in the enjoyment of apéritifs in your city/country?

Definitely! But more in refreshing mixed drinks, rather than straight apéritifs. Consumers like to enjoy Pernod Absinthe, Ricard or Suze in long drinks. I would say that in my bars Byrrh and Lillet are still a little behind, but we are working on them too!

We would love to learn more about you, your work and your approach to mixology! What would you like to share with us about you and your bar?

In 2009, after a number of years working as a seasonal bartender in hotels around the world, I decided to open Papa Doble in Montpellier,

my home town. What I like, and what I think we are doing in my bar, is making cocktails with strong flavours and intense aromas. I want people to keep coming back to experience the flavour. As far as I know, it's working well – some of my customers tell me they still have the taste of a cocktail in mind when they go to bed and before they start to dream. In 2015, we launched Baton Rouge with Joseph Biolatto, a Parisian bar located in the area of Pigalle. The concept is Louisiana, the creole culture, the 'bayou', and we use Pernod Absinthe a lot.

Do you have a signature cocktail you would like to share with us?

BYRRH STINGER

Shake well over ice and strain into a coupe glass.

60 ml Byrrh
30 ml Menthe-Pastille
4–6 fresh mint leaves

Garnish with mint leaves.

BYRRH STINGER

Fill the cocktail shaker with as much ice as possible, and shake until frost appears on the outside. This will prevent an over dilution.

FIVE QUESTIONS FOR FABIEN MAILLARD

The magic five French Classics: Pernod, Ricard, Byrrh, Suze and Lillet were all number one bestsellers in the French market in their 20th-century heyday. What importance do these French products represent for you in today's mixology?

Each represents the ingredient of a classic cocktail, revisited with recipes from old cocktail books. These five, well-known brands, some almost forgotten in the meantime, have enabled us to go back in time in our own bar, exploring new tastes that symbolise French knowledge.

Imagine you had to create a bar just for your friends – what would it be like?

A bar is the one place where everybody comes together. I would create a warm, timeless space, which would allow everyone to feel as if they were at home. The bar is a place of discovery. I would offer a selection of top quality spirits and liqueurs and fresh ingredients. The bar would be circular, so everyone can see each other and also go behind the counter to create their inspiration of the moment. They're all my friends, so naturally they love a bar!

Have you noticed a renaissance in the enjoyment of apéritifs in your city/country?

Cocktail culture is booming. More people are looking for pleasure, and quality over quantity. The apéritif, synonymous with sharing and relaxation, plays an increasing part in the cultural habits of the Quebec. People are becoming more open-minded about vintage products.

We would love to learn more about you, your work and your approach to mixology! What would you like to share with us about you and your bar?

After graduating in culinary arts and hospitality management, I stepped behind the bar for the first time a little over 20 years ago in Paris.

As they say, the rest is history, with experience that spans from Japan to the Caribbean. I am inspired by history and travel, and have spent time competing in both mixology and bartending competitions around the world. On my return to Montreal, I became the founder and owner of the Lab Comptoir à Cocktails, since 2008 considered one of the city's top cocktail bars. From behind my incredibly well-stocked bar, I have been able to pursue my passion for the craft of bartending and have earned a reputation for creative recipes. Today, the Lab Comptoir à Cocktails has two locations in Montreal, one on the plateau Mont-Royal and one Downtown.

Do you have a signature cocktail you would like to share with us?

LEBEAUPIN COCKTAIL

Stir well over ice in a mixing glass and strain in a coupe glass.

2 dashes of Lab Bitter Lime Tonic (homemade bitters)
40 ml Byrrh
20 ml Suze
10 ml lime and ginger liqueur

Garnish with a long rind of grapefruit.

LEBEAUPIN COCKTAIL

For a perfect rind of grapefruit, use a vegetable peeler, then pinch the rind over the cocktail to transfer the perfume and essential oils.

DELICATESSEN
Sadovaya-Karetnaya ul., 20, cpt. 2, Moscow, Russia
www.newdeli.ru

FIVE QUESTIONS FOR SLAVA LANKIN

The magic five French Classics: Pernod, Ricard, Byrrh, Suze and Lillet were all number one bestsellers in the French market in their 20ᵗʰ-century heyday. What importance do these French products represent for you in today's mixology?

These French products give freshness to our cocktails and can be used in so many different ways. But for us, they are not classics. They are new products, as we have only been introduced to them in the last few years. They are new and exciting and will allow us to bring new twists to our more classical cocktails.

Imagine you had to create a bar just for your friends – what would it be like?

It would be a small bar with a maximum of 26 people, and a short cocktail list based on the classics, but with a wide range of spirits. And on the second floor, we would have an apartment!

Have you noticed a renaissance in the enjoyment of apéritifs in your city/country?

We can talk of a renaissance indeed, because up to a few years ago here in Moscow absinthe was just used in shots and flaming drinks. Now, a new generation of bartenders is not only paying attention to the history of Suze, Byrrh and Lillet, but is inspired by their possibilities, and our guests are interested too.

We would love to learn more about you, your work and your approach to mixology! What would you like to share with us about you and your bar?

I've been a bartender since 1991. Delicatessen was opened seven years ago by renowned bartender turned restaurateur Vyacheslav Lankin and three fellow Muscovites, all with a clear idea about the bar business and each in charge of one aspect. I am now the one in charge of the bar. We have no drinks list as such, but our team of bartenders has a fantastic knowledge of cocktails and we maintain a well-stocked bar, so customers can order whatever they like.

Do you have a signature cocktail you would like to share with us?

PARIS GREEN

Shake well over ice and strain into an old-fashioned glass over crushed ice

30 ml Pernod Absinthe
30 ml gin
15 ml homemade tarragon syrup
20 ml lemon juice

Add a spray of butterscotch liqueur and garnish with lime zest and mint.

PARIS GREEN

To ensure good zest, always choose a lime which is firm and use a vegetable peeler to separate the zest from the pith.

FIVE QUESTIONS FOR DIMITRY SOKOLOV

The magic five French Classics: Pernod, Ricard, Byrrh, Suze and Lillet were all number one bestsellers in the French market in their 20th-century heyday. What importance do these French products represent for you in today's mixology?

For me, these iconic French products represent a major step in helping my fellow Russians appreciate the classic cocktails.

Imagine you had to create a bar just for your friends – what would it be like?

It would be in French Polynesia – on the beach – with many varieties of local rum, and a Ti' Punch cocktail. Every bartender dreams of owning a very small bar, where he can work alone. To mine I would like to add a second floor, where we could all stay. So if we drink and don't want to go home, I would have a place for me and my guests upstairs.

Have you noticed a renaissance in the enjoyment of apéritifs in your city/country?

For a long time, apéritifs were simply not available in Russia. We heard about them of course, but could only dream! So now we have these amazing products available, offering flavours that are both strong and fresh, and it is incredibly interesting for us to have the opportunity to twist these products into classic apéritifs to appeal to our own market.

We would love to learn more about you, your work and your approach to mixology! What would you like to share with us about you and your bar?

I started bartending in 1998 and now own three places in Moscow: Mr Help & Friends, Lawson's Bar and Stay True Bar. Mr Help & Friends is not just a bar. I am proud to say that it was the first cocktail bar in Russia, established in 2004. At the time, cocktails in Moscow were considered expensive and therefore not very popular. So I decided to lower the prices, while continuing to offer customers a variety of the best cocktails available. Our mission is to develop a true cocktail culture and we have created a menu to help our customers better understand what they are drinking and ultimately enjoying.

Do you have a signature cocktail you would like to share with us?

IRON LADY

Shake well and strain into an old-fashioned glass over ice.

20 ml Lillet Blanc
40 ml homemade camomille-infused Scotch whisky
15 ml white cacao liqueur
30 ml lemon juice
Dash of orange bitters

Garnish with orange peel.

IRON LADY

Make sure you fill your cocktail shaker with ice and shake until the outside is well frosted. This will add flavour to the cocktail and make it colder.

FIVE QUESTIONS FOR MAURO MAHJOUB

The magic five French Classics: Pernod, Ricard, Byrrh, Suze and Lillet were all number one bestsellers in the French market in their 20ᵗʰ-century heyday. What importance do these French products represent for you in today's mixology?

These products play a very important role for all bartenders. They are landmark, historical products, which are back in fashion right now. You can't do without them in a serious American bar!

Imagine you had to create a bar just for your friends – what would it be like?

I am a traditional and classic bartender, so it would definitely have to be a classic bar, serving a selection of quality, vintage products.

Have you noticed a renaissance in the enjoyment of apéritifs in your city/country?

In Munich, my home city, enjoyment of the apéritif is growing steadily, but for now it is still a trend for the cognoscenti. An apéritif is not yet the first drink a customer is likely to order at the bar.

We would love to learn more about you, your work and your approach to mixology! What would you like to share with us about you and your bar?

My career as a bartender began in Bologna in 1989. Before that, I ran hotels and American bars on the Adriatic coast. I teach, give seminars and master classes about bartending, and am a judge at bartending competitions around the world. I am also a researcher and historian in everything to do with the bar. I have lived in Munich since 1994. I owned Negroni from 1998 until 2009 and today own Mauro's Negroni Club. I have won national and international bartending competitions, including the 2002 Bavaria 'Bartender of the Year' award. I am a

member of various bartenders' associations and the owner of a large collection of bar books and tools. And finally I am the inventor of the Negroni Category!

Do you have a signature cocktail you would like to share with us?

OPPORTUNITY

Stir well over ice in a mixing glass and strain in a coupe glass.

35 ml Bourbon
15 ml Byrrh
10 ml Suze
10 ml Aperol
Dash of rhubarb bitters

Garnish with orange zest and grated chocolate.

OPPORTUNITY

It is important to achieve an aromatic drink with this kind of cocktail, so make sure you chill the mixing glass by first stirring the ice on its own. Strain out any remaining water before adding the ingredients.

EST. 1915

DANTE
NEW YORK CITY

DANTE
79–81 Macdougal St, New York, NY 10012, USA
www.dante-nyc.com

FIVE QUESTIONS FOR NAREN YOUNG

The magic five French Classics: Pernod, Ricard, Byrrh, Suze and Lillet were all number one bestsellers in the French market in their 20th-century heyday. What importance do these French products represent for you in today's mixology?

These products are certainly very important, especially Pernod Absinthe, Lillet and Ricard, but many Americans would consider them niche products. Bartenders are finding new ways for their customers to appreciate them by using them in modern cocktails. It is nice to see products like Suze, Byrrh and Ricard becoming a little more popular. There is still a fair way to go in terms of educating the general public, but these products have their place in any good cocktail bar.

Imagine you had to create a bar just for your friends – what would it be like?

It would be on a beach somewhere – a shack. Something very simple, no dress code, blended drinks, cold beer, fresh seafood, pretty chilled.

Have you noticed a renaissance in the enjoyment of Apéritifs in your city/country?

Absolutely! Apéritifs have become so much more popular in America in the last three years, especially in New York. Local bars have sections on their menus where they'll have three, four or five apéritifs. It's such a beautiful way to start the evening with these light, refreshing, elegant drinks. At Dante it's our whole concept and philosophy, so it's very exciting.

We would love to learn more about you, your work and your approach to mixology. What would you like to share with us about you and your bar?

I've been bartending for 20 years. My bar is in Manhattan and is called Dante. We have a very unique concept, I think, for America. It's

all about aperitivos from different parts of Europe, not just France, Italy or Spain. We try to have a very broad range of apéritifs. It's been a very successful formula for us, and people are definitely drinking in this way now. It's much more civilised and elegant, we're inspired by the grand cafés of Europe.

Do you have a signature cocktail you would like to share with us?

SUMMER 2017

Shake well with ice and strain into a highball glass over ice.

45 ml Lillet Rosé
15 ml Vodka
15 ml salted strawberry and rhubarb cordial (homemade)
10 ml lemon juice
5 drops of rhubarb bitters
45 ml watermelon juice

Garnish with 3 watermelon radish slices.

To ensure this cocktail is as refreshing as possible, use fresh watermelon while it is in season.

FIVE QUESTIONS FOR NICO DE SOTO

The magic five French Classics: Pernod, Ricard, Byrrh, Suze and Lillet were all number one bestsellers in the French market in their 20ᵗʰ-century heyday. What importance do these French products represent for you in today's mixology?

Well, first it's part of our heritage, but also they are all very good products. Even if you are not French you should stock them in your back bar or fridge. Each one of these French products is vital for making either classic or modern classic cocktails.

Imagine you had to create a bar just for your friends – what would it be like?

Made of pandan leaves. Only joking! It would be a small and intimate room. No tables, just seats at the bar. The bar would be like a small lab, with lots of homemade ingredients. Every spirit I like would be there, but nothing more. Lots of milk punches on tap. A little space for someone DJ-ing. It would be a mix between Berlin and Brooklyn.

Have you noticed a renaissance in the enjoyment of apéritifs in your city/country?

Yes, there is a big renaissance in France and in New York City also. Low alcohol cocktails are trendy these days. At last! And Suze is used a lot, which is amazing!

We would love to learn more about you, your work and your approach to mixology. What would you like to share with us about you and your bar?

The label 'travelling mixologist' is actually not inappropriate in my case. I love to travel – backpacking. I've been to 70 countries, and I always try to introduce flavours and smells from my travels into my drinks, using such modern techniques as sous-vide, centrifuge, fat-washing etc. My two favourite cities are New York and my hometown of Paris and I'm lucky enough to have opened a bar in each, which are both very successful. Mace made the World's 50 Best Bars for the second year in a row, and is a spice-driven, focus bar. Danico has just been nominated on the short list for best new bar in Europe at the Berlin Bar Show.

Do you have a signature cocktail you would like to share with us?

L'ALLIGATOR C'EST VERT

Shake well over ice and strain into a coupe glass.

30 ml Pernod Absinthe
30 ml coconut milk
30 ml homemade salted pandan syrup
1 egg

Garnish with nutmeg.

L'ALLIGATOR C'EST VERT

To enhance the elegant rich texture of this cocktail, fill your cocktail shaker with ice and shake the ingredients until the exterior is well frosted.

FIVE QUESTIONS FOR RÉMY SAVAGE

The magic five French Classics: Pernod, Ricard, Byrrh, Suze and Lillet were all number one bestsellers in the French market in their 20th-century heyday. What importance do these French products represent for you in today's mixology?

For a French bartender working in a French bar, these products are incredibly precious. Firstly, they are part of our bartending heritage and, secondly, their flavour profile makes them tremendously interesting to work with.

Imagine you had to create a bar just for your friends – what would it be like?

A bar just for my friends? It would be very similar to Little Red Door! A place for everyone to have fun, relax and discover new flavours and ideas.

Have you noticed a renaissance in the enjoyment of apéritifs in your city/country?

Very much so! France has always loved apéritifs and always will, but right now, instead of having a beer or a straight spirit, the French love to rediscover classics like the Pernod and Ricard products. I also think that guests at Little Red Door are more and more quality aware and looking for quality products. Well-crafted cocktails, steeped in history and tradition, carry a lot more appeal for our customers today.

We would love to learn more about you, your work and your approach to mixology! What would you like to share with us about you and your bar?

'Behind every Little Red Door is a wonderful world' is our motto and we try to live up to it every day. The bar is located in the Marais in Paris and we focus on providing a very personal, friendly service and a unique drinking experience. Our customers are knowledgeable and we are constantly inventive, open to individual preferences and prepared to make every visit to our bar a memorable one. This ensures that our bar remains a place of discovery in an albeit unpretentious setting.

Do you have a signature cocktail you would like to share with us?

LE BONHOMIE

Pour over ice into a highball glass with a black salt rim. Stir well.

60 ml Suze
90 ml homemade salted grapefruit juice

LE BONHOMIE

You can add a pinch of salt
to fresh grapefruit juice to
enhance the flavour of the
cocktail.

FIVE QUESTIONS FOR CARINA SOTO-VELASQUEZ

The magic five French Classics: Pernod, Ricard, Byrrh, Suze and Lillet were all number one bestsellers in the French market in their 20ᵗʰ-century heyday. What importance do these French products represent for you in today's mixology?

They are very important indeed. Bartenders always use these products in small quantities to give complexity to their creations, which is why they call them 'modifiers'. And now they are highlighting these modifiers even more than the base spirit of the cocktails. Also the apéritif cocktail has become an important category. Low ABV cocktails are very much in demand. In countries like France, where the wine culture is very strong, the revival of the cocktail has helped to diversify the apéritif ritual and, for the French, these brands are inescapable!

Imagine you had to create a bar just for your friends – what would it be like?

All our venues are thought to be a *bar des amis* ['bar for friends']. What is important is conviviality, comfort, fun and to be always accessible. The one single little difference is that friends usually don't pay!

Have you noticed a renaissance in the enjoyment of apéritifs in your city/country?

In France, the apéritif is a key ritual that sometimes replaces dinner. When you are invited for a good lunch or dinner, the time of the invitation is set by the apéritif. What has changed in Paris, my home city, is the creativity displayed in the apéritif. In the past, people used to drink the same apéritif again and again, be it beer, wine, Kir or champagne. Now, cocktails are part of the game and they twist the apéritif, making it refreshing, bright, easy to prepare and fun to try. And people are trying many new cocktails as an apéritif.

We would love to learn more about you, your work and your approach to mixology! What would you like to share with us about you and your bar?

I create venues and cocktails. I am always thinking how to impress people. The interaction of my guests with the space and with a drink is always the most important thing. And I love to create a surprise with the unexpected: unusual flavours, decoration, mood, setting, etc.

Do you have a signature cocktail you would like to share with us?

RUE ST-VINCENT

Originally created at Mary Celeste, by Carlos Madriz. Shake well over ice and strain into a coupe glass.

20 ml aquavit
20 ml Manzanilla sherry
20 ml Suze
2.5 ml crème de poire
25 ml lemon 2.5 cl
25 ml cucumber syrup
10 ml egg white

Garnish with a thin slice of cucumber.

Egg white introduces a specific texture and helps to create a nice foam on top of the cocktail. Ensure you shake the drink vigorously to make this happen.

FIVE QUESTIONS FOR SAM KUAN

The magic five French Classics: Pernod, Ricard, Byrrh, Suze and Lillet were all number one bestsellers in the French market in their 20th-century heyday. What importance do these French products represent for you in today's mixology?

These apéritifs represent not only the special ingredients in the cocktails, but also the history of the cocktail and the ideas people have about French culture. Nowadays, thanks to the Internet, bartenders around the world work much more closely together. These essentially French products will be easier to showcase worldwide, giving Asian bartenders the opportunity to get to know them and to offer customers better cocktails as a result.

Imagine you had to create a bar just for your friends – what would it be like?

I think it could take two forms. Either a little bar, for a maximum of 15 people, like the Izakaya in Ginza, Japan, ensuring friends get very close to their host; or it could be a themed bar, like a Tiki-style or rock 'n' roll-style bar, offering friends a series of special moods.

Have you noticed a renaissance in the enjoyment of apéritifs in your city/country?

Asia is not a region with a habit of drinking apéritifs. Normally, people drink spirits (strong drinks) during dinner. But in recent years, largely due to the promotion of cocktails by spirits brands and bartenders, consumers have started to discover and drink apéritifs.

We would love to learn more about you, your work and your approach to mixology! What would you like to share with us about you and your bar?

Barules is a British Prohibition-era cocktail bar, located at the French Concession of Shanghai. I come from Taiwan originally and like to com-

bine elements of cocktails from London, New York and Japanese cultures. I plan to build an innovative cocktail culture in Shanghai by presenting cocktails with specific food, in creative containers and with fancy decorations. Barules consists of two floors with different styles. The first floor is retro, luxurious but not flamboyant. Cocktails served on the first floor are typically made of fresh fruit. Neo Soul, disco, funk and house music is played on the first floor. The second floor named 'L', represents 'Life, Luxury and Legend'. You will find a quieter, more elegant style on the second floor. In addition to rare Scotch whisky, the idea is to present more delicate and high-end special cocktails. If you are a connoisseur of cocktails, then the second floor will bring you lots of surprises and satisfaction. At Barules you will never see frustrated faces!

Do you have a signature cocktail you would like to share with us?

BLOOM BLOOM

Pour over ice into a copper mule mug. Stir well.

45 ml dry gin
25 ml Byrrh
10 ml Suze
20 ml lemon juice
15 ml honey syrup

Top with tonic water and garnish with a grapefruit wheel.

BLOOM BLOOM

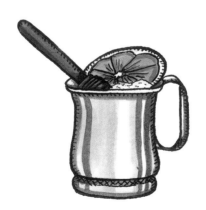

Dehydrate the grapefruit wheel
for a strong, vintage appearance
to your cocktail.

FIVE QUESTIONS FOR PATRIK TAPPER

The magic five French Classics: Pernod, Ricard, Byrrh, Suze and Lillet were all number one bestsellers in the French market in their 20ᵗʰ-century heyday. What importance do these French products represent for you in today's mixology?

If I were a chef, I would say that what really makes an exceptional soup is the broth. As a bartender, these five French classics represent the very best ingredients I could hope to work with. You add a bar spoon of Pernod Absinthe and a splash of Lillet and voilà, you've lifted your cocktail to new heights! But just like a broth, each can be enjoyed on its own. You rarely see drinks actually based on these products, and yet cocktails would be unimaginable without them. There would be no Vesper, no White Negroni and definitely no Corpse Reviver No. 2.

Imagine you had to create a bar just for your friends – what would it be like?

I like to think that a bar is made of people. So in a bar for my friends, everyone would have to bring at least one friend with them every time they came by. It would be a small place, serving a great mix of cocktails and Pho, a Vietnamese noodle soup. My bar would be open really late, so you could go for something to eat, recap on the amazing night you had with your friends, before splitting and heading home.

Have you noticed a renaissance in the enjoyment of apéritifs in your city/country?

Yes! Binge drinking at the weekend after a dry week is disappearing. We are experiencing a continental style of drinking, spread out during the week and focused on quality rather than quantity, and this is exactly what the apéritif is about. Lots of flavour, but less alcohol – a win-win for anyone who likes to go for 'After Work', which people in Sweden seem obsessed about.

We would love to learn more about you, your work and your approach to mixology! What would you like to share with us about you and your bar?

I work at the well-established Linje Tio at Tjoget in Stockholm, a restaurant/cocktail bar with Mediterranean and Middle Eastern influences, both in food and cocktails. We are a small team, who work closely together, pushing ourselves to achieve something special and unique. It's a lively workplace with constant activity. We open early and carry on until late into the night. For me, it's always been about fun. If you don't have fun doing this job, it might prove to be one of the worst jobs there is. But if you do have fun, it's most definitely the best job there is. Naturally, there is a lot of hard work behind it as well, and that's what makes it all worth it.

Do you have a signature cocktail you would like to share with us?

GARDEN BY THE CHARENTE

Muddle fresh peaches into a shake, add other ingredients and shake. Strain into an old-fashioned glass, filled with crushed ice.

1 fresh peach
30 ml Byrrh
30 ml fennel-infused cognac
10 ml crème de pêche
20 ml lemon juice
10 ml sugar syrup
2 dashes of Pernod Absinthe
2 dashes of Peychaud bitters

Garnish with a peach wedge and a sprig of mint.

Ensure you use a fine strainer when pouring your cocktail to produce a good homogeneous texture.

BAR BENFIDDICH
Nishishinjuku, 1 Chome-13-7, 160-0023 Tokyo, Japan
www.facebook.com/BarBenfiddich

FIVE QUESTIONS FOR HIROSAYU KAYAMA

The magic five French Classics: Pernod, Ricard, Byrrh, Suze and Lillet were all number one bestsellers in the French market in their 20ᵗʰ-century heyday. What importance do these French products represent for you in today's mixology?

I have always loved working with classic apéritifs and, in fact, I have got into the habit of buying vintage bottles in France and bringing them back with me to Japan, to use them in special cocktails in my bar. Pernod Absinthe is a special favourite of mine and particularly important because the flavours of anise and fennel help the taste of the cocktail to linger on the palate almost indefinitely.

Imagine you had to create a bar just for your friends – what would it be like?

I am interested in traditional elixirs and herbal infusions and am forever conducting experiments on my customers. So I would create a bar for my friends where we could try out all sorts of new flavours and make cocktails with herbs that are homegrown on my family plot in Chichibu, Saitama. My clients like to experiment, and I know my friends would too!

Have you noticed a renaissance in the enjoyment of apéritifs in your city/country?

There are very few opportunities to drink apéritifs in Japan at the moment, I believe. But we want to introduce this culture here and to make it as visible and widespread as possible.

We would love to learn more about you, your work and your approach to mixology! What would you like to share with us about you and your bar?

I worked as head bartender at Amber, a mixology bar in Nishi-Azabu, before becoming the owner of Bar Benfiddich in Tokyo. The bar opened in July 2013 and we have gained

a reputation for our apothecary-style cocktails using a variety of herbal ingredients and spices. I'm fascinated by absinthe and also interested in French history, so before I opened the bar, I made a trip to France and went to Pontarlier and to Val-de-Travers to study absinthe with local producers.

Do you have a signature cocktail you would like to share with us?

FRENCH SOUR

A very popular cocktail in my bar!
Shake well over ice and strain into a coupe glass.

45 ml Martell
20 ml Grand Marnier
10 ml fresh lemon juice
10 ml egg white
5 ml Pernod Absinthe

Garnish with a dried absinthe sprig.

FRENCH SOUR

Absinthe is strong and very fragrant, so always ensure you measure the quantity you add to any cocktail by using a bar spoon.

TRENCH

BAR TRENCH
Ebisu-nishi 1-5-8 / 102, Shibuya-ku, Tokyo, Japan
www.small-axe.net/bar-trench

FIVE QUESTIONS FOR ROGERIO IGARASHI VAZ

The magic five French Classics: Pernod, Ricard, Byrrh, Suze and Lillet were all number one bestsellers in the French market in their 20ᵗʰ-century heyday. What importance do these French products represent for you in today's mixology?

These five French Classics have played an important role in cocktails, not just today, but over the last century as well. They are connecters to the other spirits, an enhancer of flavours and they give extra depth to the cocktail. Consumers nowadays have a preference for something more complex in their cocktails. A simple sweet or dry vermouth would lack flavours, while adding a dash of Byrrh or Lillet will provide the floral and delicate nuance they are looking for.

Imagine you had to create a bar just for your friends – what would it be like?

It would not be perfect, as I would keep it as simple as possible. I would have just a few bottles and switch drinks whenever one was empty. I would stock three spirits: whisky, rum and gin, and serve just one apéritif depending on the season. So, in winter it would be sweet vermouth, in summer dry vermouth, in spring Lillet and in autumn Byrrh. I would use the same seasonal pattern for amaro and bitters: Suze in spring, Angostura during the summer, Gammel Dansk in autumn and orange bitters in the winter. And so on.

Have you noticed a renaissance in the enjoyment of apéritifs in your city/country?

I have seen a growth in the enjoyment of apéritifs on other continents and it is starting to happen in Japan too. I believe it will develop over the coming years because the Japanese have an affinity for all things herbal. So there is a big chance of a major apéritif trend happening here soon.

We would love to learn more about you, your work and your approach to mixology! What would you like to share with us about you and your bar?

I am Brazilian of Japanese descent and have been mixing drinks in Tokyo for over 15 years. I learned bartending in Japan and always try to incorporate some South American vibe into my drinks – a blend of East and West. Bar Trench has a penchant for all things herbal, from vermouths to absinthes, serving not only classic but modern cocktails as well. Located in the centre of Tokyo with only twelve seats, Bar Trench has been a retreat for locals and international consumers since 2010.

Do you have a signature cocktail you would like to share with us?

THE WORLD OF SUZIE WONG

Inspired by the hero of a 1960s British-American drama, which takes place in Hong Kong. Serve in a chilled champagne flute.

30 ml seaweed washed Suze
10 ml lime juice
10 ml white cacao liqueur
30 ml pear puree
Dash of Suze Bitters Aromatic

Top with champagne.

To ensure the minimum dilution, try to use dry ice cubes straight from the freezer.

ACKNOWLEDGEMENTS

Thank you to all those who contributed to the creation of such a unique place. To Louis XIV, who in 1660 gave orders for these ancient oaks to be planted, so that we could use them for casks 250 years later. To Alexandre Gustave Eiffel and the Violet brothers, who in 1892 created an architectural masterpiece as the location for distilling spirits. To César Giron, who in 2010 was the President of Pernod and commissioned a bar to be built. And finally to Vaughan Yates and 1751, who created a stunning design, and my friend Eric Fossard, who equipped it to perfection.

Thank you to the entire team that runs the distillery today, and especially to Bernard Pech, Head of Operations, Patrick Guidici, Site Director, Claire Thémé, Head of Research and Development, and our Master Distiller, Guy Palmerols.

A massive credit to photographer Simon Upton for capturing the distillery as the classic it is.

To Fernando Castellon, Mauro Majhoub and Mathieu Sabbagh – *merci* for lending us your collection of collectors' cocktail shakers, vintage bar tools and bottles for the shoot.

To Maison Bachès, who brought us their citrus fruits and to Sasha Molodskikh, who created the cocktails represented in these pages. If you wish to taste them, you just have to drop by his bar Le Parfum in Montpellier. The place is definitely worth a visit – for a sip or even a drink or two!

Thank you to the bartenders all over the world, who have shared their thoughts about bartending as well as one of their favourite cocktail recipes with us. Now try them at home! We have listed all their bars – see page 121 – so you can pay them a visit when you next travel abroad.

Thank you to Pénélope for illustrating the ingredients, bar tools and finished cocktails for the bartenders' interviews with so much style. Just looking at them already makes us thirsty!

Thank you to Karen Howes for writing, as well as re-writing and editing texts on Mondays, which we were usually finishing on Tuesdays or even later in the week!

Thank you to Mathieu Sabbagh – you were the first one to believe in this book back in 2015, and you are a visionary. And thank you to Mathieu Deslandes for getting it finished together.

Finally, bravo to Gerhard Steidl for allowing us to print this in your publishing house and *danke* to Monte Packham for your help and patience. Gerhard, I hope you have not read this page (yet) but I tell you now, you are a gentleman, and this is one hell of a book!

Thank you to the Pernod, Moureaux, Lillet and Violet families who created Pernod, Suze, Lillet, Byrrh in 1805, 1885, 1887 and 1892.

Thank you to Paul Ricard, the creator of Ricard in 1932, as well as to Patrick and Alexandre Ricard who have curated and ensured that these magnificent products are manufactured to perfection and distributed around the world.

INDEX

First edition published in 2017

Book design: Daniel Gaujac, Holger Feroudj, Gerhard Steidl
Photoshoot production: Interior Archive
Separations by Steidl image department

Production and printing: Steidl, Göttingen

Steidl
Düstere Str. 4 / 37073 Göttingen, Germany
Phone +49 551 49 60 60 / Fax +49 551 49 60 649
mail@steidl.de
steidl.de

ISBN 978-3-95829-270-3
Printed in Germany by Steidl